FRESH IDEAS IN

letterhead and business card design

Gail Deibler Finke

NORTH LIGHT BOOKS

cincinnati, ohio

Fresh Ideas in Letterhead and Business Card Design 4. Copyright © 1999 by Gail Deibler Finke. Manufactured in China. All rights reserved. No part of this book may be reproduced in any form or by any electronic or mechanical means including information storage and retrieval systems without permission in writing from the publisher, except by a reviewer, who may quote brief passages in a review. Published by North Light Books, an imprint of F&W Publications, Inc., 1507 Dana Avenue, Cincinnati, Ohio 45207. (800) 289-0963. First edition.

Other fine North Light Books are available from your local bookstore or direct from the publisher. Visit our Web site at www.howdesign.com for information on more resources for graphic designers.

03 02 01 00 99 5 4 3 2 1

Library of Congress Cataloging-in-Publication Data

Finke, Gail
 Fresh ideas in letterhead and business card design 4 / Gail Deibler Finke. — 1st ed.
 p. cm.
 Includes index.
 ISBN 0-89134-952-9 (alk. paper)
 1. Letterheads—Design—Catalogs. 2. Business cards—Design—Catalogs. I. Title. II. Title: Letterhead
 and business card design 4.
NC1002.L47F57 1999
741.6—dc21 98-56136
 CIP

Edited by Lynn Haller and Linda H. Hwang
Production edited by Marilyn Daiker and Donna Poehner
Interior designed by Brian Roeth
Cover designed by David Mill of Design Mill
Production coordinated by Erin Boggs

The permissions on page 139 constitute an extension of this copyright page.

Gail Deibler Finke grew up in Pennsylvania, but never heard of graphic design until her college years in Ohio. Either lack of talent or lack of discipline kept her from starting over with a new major, so she pursued a career in journalism. Fate took a hand and she now writes about graphic design from her Cincinnati home, which she shares with her designer husband and her two (perhaps future designer) children. She would like to thank her family, her editors, and her Maker for the opportunity to write about an endlessly fascinating subject. Most of all, she would like to thank the talented designers who continue to give her something to write about.

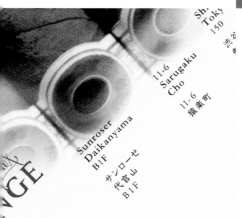

table of contents

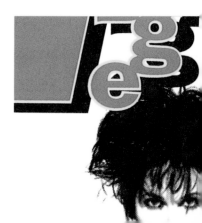

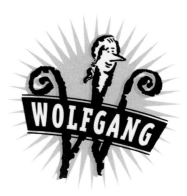

from the editor

Everyone has days when ideas are hard to find. On those days it seems as if there are only so many ideas in the world, and they've all been used up. What else can anyone do with a sheet of paper and an envelope? How much more can anyone cram on a business card? After a while, all the new typefaces start to look alike, the rainbow can't yield another exciting color and a shelf full of stock photo CDs is no better than the old days without access to photos at all.

Luckily, those days pass. The biblical proverb that there is no new thing under the sun may be correct, but people have been coming up with ways to use the old ones for centuries. That's true for graphic design. Far from becoming stale, graphic design has continued to evolve as the profession has grown. Fresh, interesting design is available to more people than ever before. The resulting proliferation of good design, which can be a daunting challenge, can also be an inspiration.

The projects in this book are outstanding examples of letterhead and business card design. Their designers have done far more than pick from a checklist of colors, typefaces and paper stocks. They've learned what their clients are about and communicated the essence of their clients' business using graphic design. They've created powerful communication tools in tiny, commonplace packages.

Some of the designs presented here rely on unusual or expensive printing techniques for their impact. A great many include heavy, textured or unusually colored papers to help make their statements—a design technique that should be more common than it is. But most simply use color, artwork and type in a memorable way. These design elements are within the reach and budgets of nearly all clients, and they're in the tool kit of every designer—even on those gray days when Helvetica looks no better than Hobo.

the basics of letterhead design

THREE (NOT SO) EASY PIECES

Why all the fuss about letterhead design? After all, letterhead for thousands of businesses—perhaps most businesses—can hardly qualify as "designed." Although the age of desktop publishing has made do-it-yourself letterhead easier than ever, it's hardly new. Printers, especially business card specialists, have long been offering "design" services. Clients simply pick from a list of typefaces, a page or two of clip art images and four or five basic type arrangements.

And some business owners—many of whom would scoff at a client's attempts to cut corners in his or her own line of work—are happy with that. But savvy business people know that letterhead makes a difference. It reflects a business's professionalism, its originality, its commitment to being better than the competition in every way.

That's a lot to ask of three little pieces of paper: a letterhead, an envelope and a business card. Some businesses can get by with only one or two of the three; some need extra note cards, envelopes, labels or forms. But those are the basics. Even the sizes are standard. In the United States, standard letterhead is 8½″ x 11″ and the standard envelope size is the no. 10 (4⅛″ x 9½″). The worldwide standard for business cards is a tiny 3½″ x 2″. Even small deviations from these norms are instantly noticeable. Just one variation—a smaller letterhead sheet, a bigger envelope, a folded business card—can itself make a client's business memorable.

Business cards are popular places for design "tweaks." Often handed out like candy and collected like baseball cards, business cards have won a warm place in the hearts of workers everywhere. But their very popularity can be the undoing of a too-clever card. If it's too difficult to store, a business card will end up in the trash. And if it's thrown in a drawer with two hundred other cards, clever design won't do it any good. When possible, a clever business card should be part of an equally clever letterhead package. That way the message will be stronger, reinforcing a strong identity rather than establishing it.

CLIENT, CLIENT, CLIENT

The key to selling real estate, it's often said, is "location, location, location." In that vein, you could say that the key to successful letterhead design is "client, client, client." If a design doesn't accurately reflect the client, it won't work, and a design that works is more important than one that looks good.

When designing letterhead, a designer's job is to play detective and find out what makes the client different from his or her competitors. Better service? A more original product? Better workmanship? Whatever that quality is, the letterhead should communicate it. The letterhead should also communicate the unique personality of the business and/or its owner. Is it formal? Casual? Outrageous? Dependable?

Another part of your client's business that you should understand is how

your product will be used. Are letters typed by a secretary? Dashed off in ball-point pen? Written by numerous people or only one? What kind of printer (or typewriter) will the letterhead be used in? Will business cards be handed out, sent with mail or picked up from displays?

Find out about your client's clients. Who are they, and what do they like? There are many solutions to any design problem. In letterhead design, the correct solution is the one that brings your client the most business. Find out if the people who will receive your client's letterhead will smile at a humorous design or discard it as frivolous. Will a high-tech look turn them on or off? Will an expensive package make them trust or distrust the sender?

If possible, go see your client's place of business. What it looks like will tell you a lot about the client's personality and style, and just might be the inspiration you're looking for. Study your client's existing letterhead (if there is one) and other materials, and those of your client's competitors. These questions are a good starting point:

- What makes your business different from others like it?
- How are you perceived by your clients and competitors? How would you like to be perceived?
- What do you like about your existing letterhead? What do you dislike? What do you like and dislike about others you've seen?
- Who will receive this letterhead?
- What is the budget?
- How will you use this letterhead, and who will use it?
- Do you like to take chances, or are you more comfortable with low-risk business (and design) decisions?

FIRST THINGS FIRST

Who hasn't picked up a business card, only to hunt for a name or address? Or dialed what they thought was a phone number gleaned from a letterhead, only to hear that annoying fax noise? Letterhead packages exist so that people can contact the businesses listed on them. If people cannot find or interpret contact information, then the design is a failure no matter how attractive it is.

That information will vary by business, but almost always includes the business name, phone number and address. It can also include employee names, facsimile and toll-free numbers, E-mail addresses, post office box numbers and many other vital bits of information. These, of course, must often be combined with corporate logos, slogans and other design elements—sometimes not very attractive ones.

But there can be infinite combinations. Text can be in one block, or two, or three or more. Text can be in horizontal or vertical lines, or in diagonal lines, curves or spirals. It can even be scattered about the page in a truly cavalier manner—assuming (and it's a big assumption) that the intended audience cares to

read such a thing. There's plenty of room in letterhead design for big ideas, bold graphics and even inscrutable design. But take care of first things first, and make certain that your client can be identified.

GETTING DOWN TO BUSINESS

A typical, uninspiring letterhead is printed in black on white laid paper. It has a couple of lines of type, a staid logo and lots of white space. You can read it all right, but it leaves lots of room for improvement. Where is the best place to start?

That depends, of course, on your client and your client's business. The key

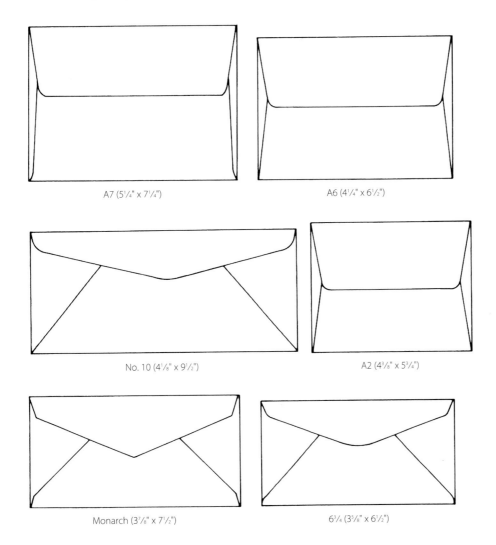

A7 (5¼" x 7¼") A6 (4¼" x 6½")

No. 10 (4⅛" x 9½") A2 (4⅜" x 5¾")

Monarch (3⅞" x 7½") 6¾ (3⅝" x 6½")

Envelopes are either stock or converted. Stock envelopes are made and then printed; converted ones are printed and then cut and folded. Stock envelopes are less expensive in small quantities and available with little lead time; however, they don't come in all paper grades.

You can have converted envelopes made from any paper, but it generally takes about four weeks. You'll also need to order about 25,000 to make envelope conversion a cost-effective option. The main reason for choosing an envelope conversion, however, is the printing technique to be used. Embossing, thermography and bleeds often do not work as well on stock envelopes.

elements common to any letterhead design are color, type, paper, printing, logos and artwork. Some businesses benefit from emphasizing one, some from another, some from all at once.

COLOR: Whatever your client's budget, color can be a vital part of the letterhead design. A low-budget design doesn't have to be black and white (though sometimes that's the best solution). Colored inks, colored papers or both can add subtle distinctions or make bold statements. Countless colored, metallic and fluorescent inks put the rainbow at every designer's disposal.

TYPE: Type has never been as varied or accessible as it is today. From established type houses to alternative "font shops," designers have a vast array of type choices at their fingertips. Yet some typefaces still crop up over and over again. Some are classics; others are merely trendy. All are far more expressive than most of your clients know, so don't be afraid to offer alternatives. Custom fonts and hand-lettering are other options.

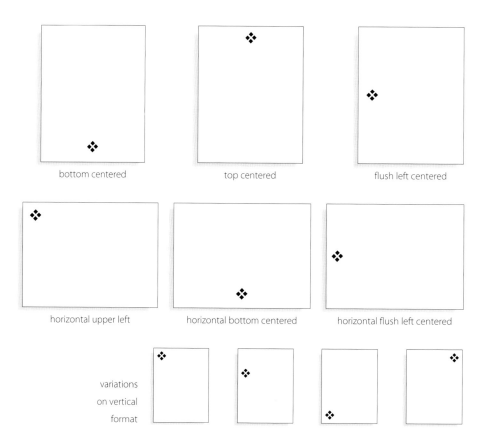

bottom centered top centered flush left centered

horizontal upper left horizontal bottom centered horizontal flush left centered

variations on vertical format

The traditional placement of the logo, company and address is in the upper-left corner of the sheet, but you can, in fact, put them just about anywhere. Let your design suggest the placement. If you are doing a strongly symmetrical design, placing the information anywhere but the top center of the sheet may throw the design off entirely. However, a design that suggests motion might call for placement in the upper left or even in the upper right. Remember that the paper is to be typed and written on. Don't let your design get in the way of communication unless there is a compelling reason to do so.

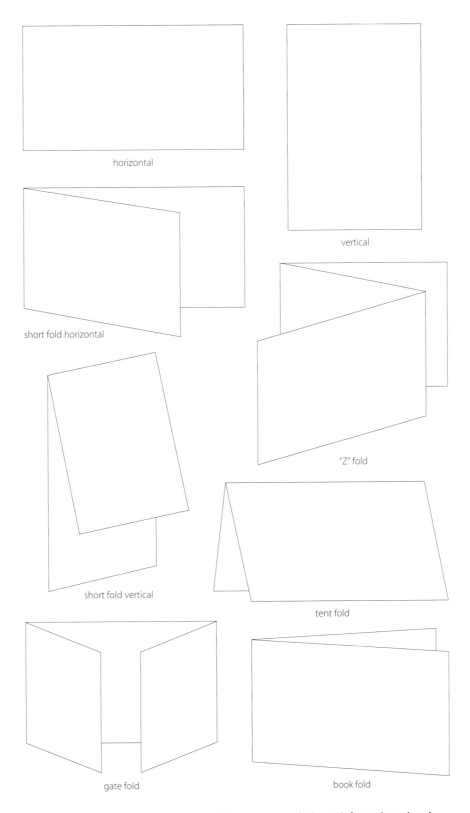

horizontal

vertical

short fold horizontal

"Z" fold

short fold vertical

tent fold

gate fold

book fold

Business cards can be folded or unfolded. They can have a design or information printed on one side or both sides; the choices are virtually limitless. A business card, however, should be durable and easy to carry. Because cards are handled frequently, they should be printed on a heavy weight of paper, for example, 65-lb. or 80-lb. cover stock. Most business cards measure $3\frac{1}{2}''$ x $2''$, but through folds and die cuts, many kinds of cards may be produced. If the business card will be folded, have it scored on the press to ensure accuracy.

PAPER: Textured, colored, recycled or coated papers can make a huge—and often overlooked—impact on letterhead. Even small print shops stock or can order unusual papers. Fine linen papers have signaled quality and expense for years. Speckled papers or papers with unusual content (one company makes paper from recycled denim) can communicate novelty. And don't underestimate the usefulness of unusual weights. Very heavy papers, such as cover and index stocks, can make a letterhead seem important. Very light stocks, including transparent vellums, can make a client seem upscale and elegant.

PRINTING: Most letterhead is printed with offset lithography, which offers more options than most people use. But there are other printing methods, all of them distinctive. Letterpress and engraving produce crisp, embossed images. Thermography (popular for business cards) creates raised, glossy printing. Screenprinting inks give a piece rich, saturated color. Die cuts, foil-stamping (a specialty printing service), varnishes and a variety of other printing "tricks" can help a piece to stand out.

LOGOS: Most established companies have corporate logos that must be included on their letterhead. Designing a corporate identity is a discipline in itself, far beyond the scope of this book. Using an existing corporate identity is another matter. Even an outdated or downright ugly logo can, if used creatively, be part of a fresh new design.

ARTWORK: Illustrations, photography, patterns and even clip art are only some of the artwork possibilities for letterhead design. Artwork gives a piece personality, communicating without words and targeting the emotions. Using scanners and laser printers, even clients with small budgets can reproduce personal photos and copyright-free images. For even less money, but requiring much more work, clients can decorate their letterhead with rubber stamps, markers and other artwork. This method of decoration is popular with artists, illustrators and craftspeople.

CAN THEY AFFORD YOU?

Some clients expect to pay thousands for their letterhead. Others balk at paying hundreds. Whether they're start-ups, nonprofits, hobbies or plain old small businesses, many businesses can't afford to spend a lot of money on letterhead. For them, extravagances such as embossing, varnishes and four-color printing are out. But does their letterhead have to be dull?

Not at all. There are time-honored ways to save money and still get a big impact. Many of the designs in this book are low-budget projects, and not all of them are in the low-budget chapter. Take a good look at how they cut costs, and soon you'll see a low budget as a challenge, not a handicap.

A HANDBOOK OF GREAT DESIGN

Many designers collect books of great projects, which they may refer to disparagingly as "swipe files." But you can't "swipe" a great design because what makes a great design great is that it fits its client. It won't fit anyone else. Instead of being an Excalibur, making anyone who wields it invincible, a purloined design brings its copier bad luck. The client won't be satisfied, and the designer won't prosper.

This book is not a swipe file. It is, on the contrary, a handbook of great design. The best way to use it is to examine each winning entry and ask these questions: How does it fit its client? How do the type, illustrations, paper stock and printing work together? What can I tell about the company before reading the description? Why would another choice in layout or color have been weaker?

In letterhead and business card design, producing nice layouts and stunning graphics is only half the battle. Solving your clients' design problems is the other half. Learn to think like the designers featured in this book— create practical and aesthetic designs targeted to your client (and your client's clients). Represent them, not as you think they ought to be, but as they are. Your work is sure to do its job. Then you will, indeed, be a great designer.

image

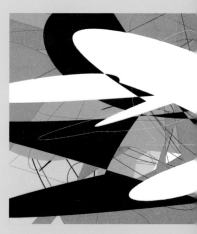

Some designs need no illustrations. Others hinge on a memorable image. All of the designs in this chapter emphasize an arresting image or series of images. Other design elements work with that central image to create a distinct identity.

Some of the designs showcased here use strong colors and bold photographs or illustrations. Others depend on delicate lines and soft colors. Some designs cover the page and spill onto the back; others sit comfortably in a corner surrounded by white space. But all convey an instant impression of the client.

Because of their immediacy and the strong (sometimes negative) reactions they can command, designs that feature images aren't right for every client. But for the right clients, they can be powerful communication tools.

As you look through this chapter, study the images these pieces create. Imagine that you've just gotten a letter from one of these businesses, or that you've just been handed one of these business cards. What do these pieces say about the businesses that commissioned them? What do you learn in one glance? What do you learn after spending time looking at them? And how do the graphics and the various elements that make them communicate that story?

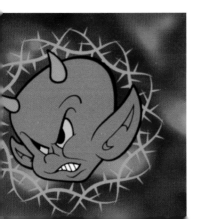

art director/studio Kristi Antonneau/Neo Design, Inc.
designer/studio Kristi Antonneau/Neo Design, Inc.
illustrator Kristi Antonneau
client/service Joy Tree, Inc./jewelry design and manufacturing
paper Wausau Astro Parchment Natural
type Custom
colors Four, match
printing Offset lithography
software Adobe Photoshop, QuarkXPress, Fontographer

concept The colorful logo design is based on the firm name, the jewelry design style based on Eastern mythology and fashion industry norms. The stationery package builds on the logo, using custom type, a branch from the logo's tree and a distinctive faded green edge to create a memorable impression.

cost-saving techniques The client needed large quantities of stationery but was building a factory and would move within a year. To avoid paying twice for four-color printing, the designer kept address information in black, then had 10,000 stationery sheets printed in color. Printing the new address will be a quick and inexpensive job.

cost $5,000 (logo); $2,700 (stationery design); $8,700 (printing)

print run 10,000 (preprinted)/1,000 (printed letterhead); 2,500 (note cards and envelopes)

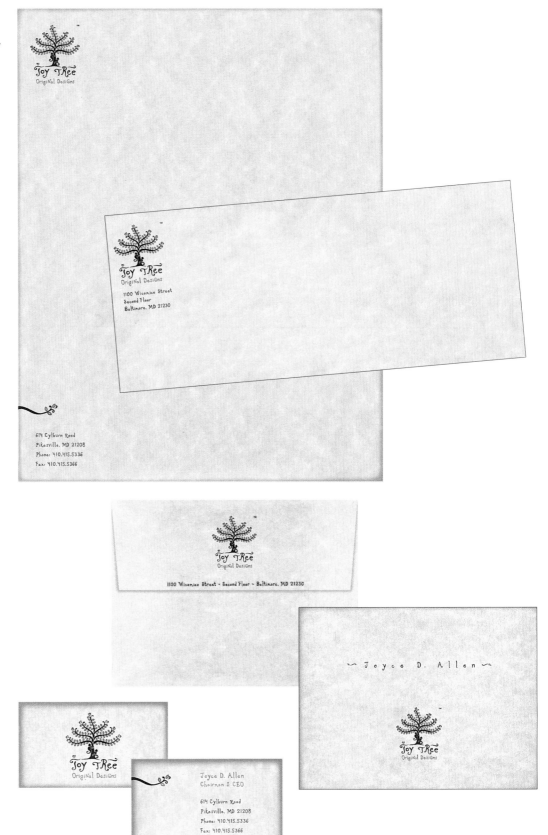

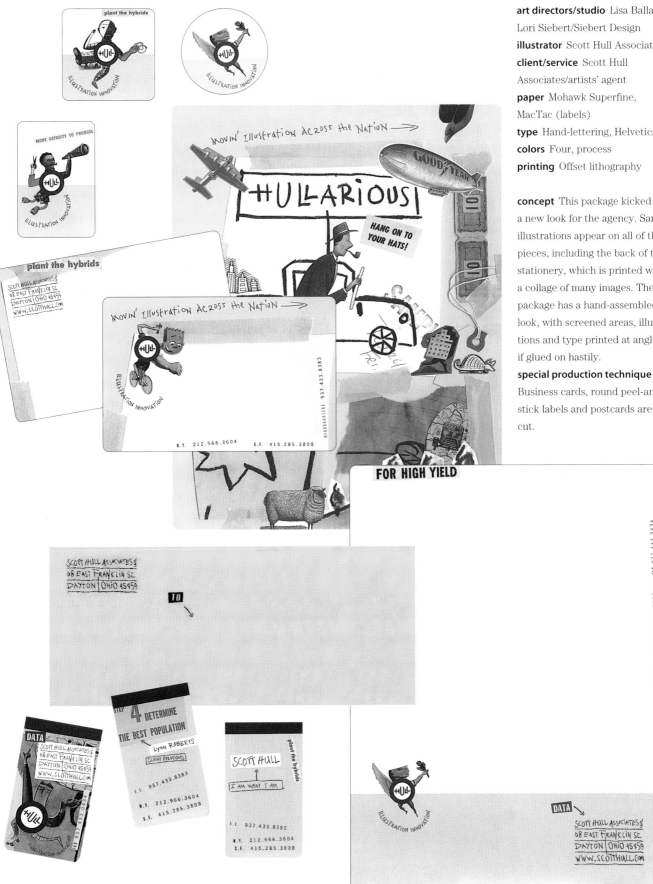

art directors/studio Lisa Ballard,
Lori Siebert/Siebert Design
illustrator Scott Hull Associates
client/service Scott Hull
Associates/artists' agent
paper Mohawk Superfine,
MacTac (labels)
type Hand-lettering, Helvetica
colors Four, process
printing Offset lithography

concept This package kicked off
a new look for the agency. Sample
illustrations appear on all of the
pieces, including the back of the
stationery, which is printed with
a collage of many images. The
package has a hand-assembled
look, with screened areas, illustra-
tions and type printed at angles as
if glued on hastily.
special production technique
Business cards, round peel-and-
stick labels and postcards are die
cut.

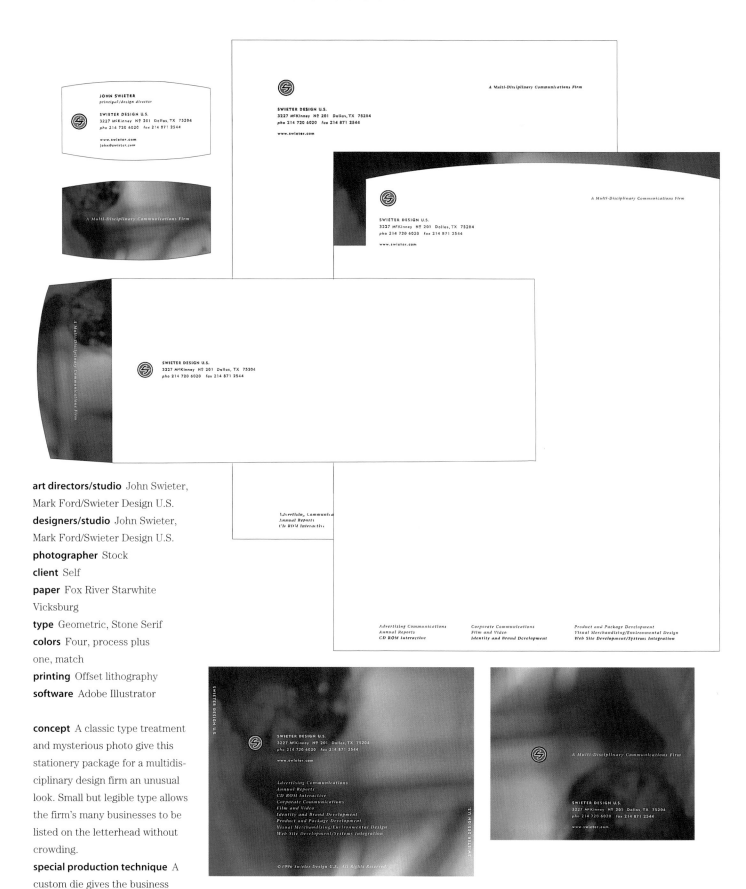

art directors/studio John Swieter, Mark Ford/Swieter Design U.S.

designers/studio John Swieter, Mark Ford/Swieter Design U.S.

photographer Stock

client Self

paper Fox River Starwhite Vicksburg

type Geometric, Stone Serif

colors Four, process plus one, match

printing Offset lithography

software Adobe Illustrator

concept A classic type treatment and mysterious photo give this stationery package for a multidisciplinary design firm an unusual look. Small but legible type allows the firm's many businesses to be listed on the letterhead without crowding.

special production technique A custom die gives the business cards their unusual shape.

print run 6,000

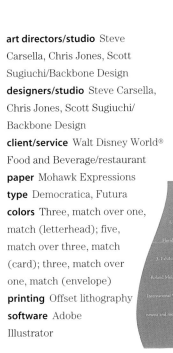

art directors/studio Steve
Carsella, Chris Jones, Scott
Sugiuchi/Backbone Design
designers/studio Steve Carsella,
Chris Jones, Scott Sugiuchi/
Backbone Design
client/service Walt Disney World®
Food and Beverage/restaurant
paper Mohawk Expressions
type Democratica, Futura
colors Three, match over one,
match (letterhead); five,
match over three, match
(card); three, match over
one, match (envelope)
printing Offset lithography
software Adobe
Illustrator

concept This fresh package
for the Cítricos restaurant at
Disney's® Grand Floridian Resort
& Spa is done in "citrus" colors,
with a dash of eggplant purple for
contrast. The design is meant to
invoke the restaurant's mission to
provide Florida cuisine with a
Mediterranean zest.

special production techniques
The envelope was printed before
conversion. Two-sided business
cards were die cut and folded.
The elaborate invitation for the
restaurant's grand opening was
die cut, folded, glued and hand-
assembled. The cards included
individual invitations, printed on
vellum and slipped into a die-cut
frame.
print run 5,000

21

art director/studio Petrula Vrontikis/Vrontikis Design Office
designer/studio Peggy Woo/ Vrontikis Design Office
photographer Peggy Woo
client/service Global-Dining, Inc./Tokyo wine, cigar and jazz club
paper Neenah Classic Crest Natural White
type Garamond (main)
colors Four, process
printing Offset lithography
software QuarkXPress, Adobe Illustrator

concept A line of cigars, their images fuzzed by white smoke, gives the viewer an instant impression of the club and its character. Warm colors create an inviting feeling. Although the lettering in the club's identity is a bit odd, it creates the desired impression in its Japanese audience. Essential information is presented in eminently readable Garamond and equally clear Japanese characters.
cost $25,000
print run 2,000

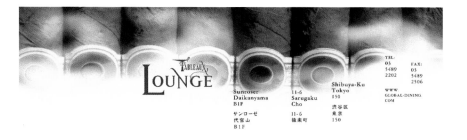

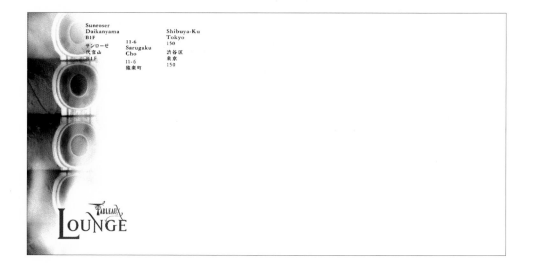

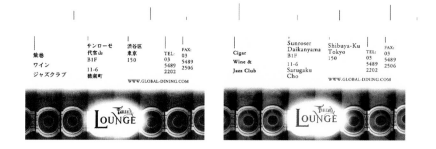

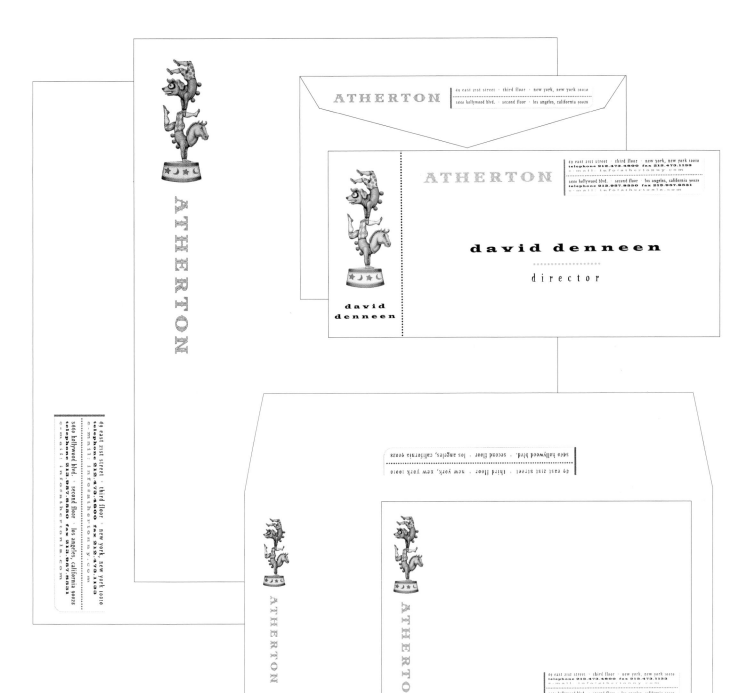

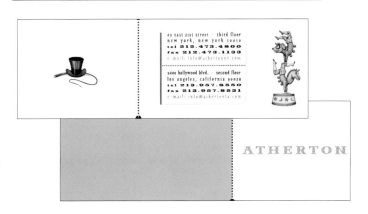

creative director/studio Margo Chase/Margo Chase Design

art director/designer/studio Brian Hunt/Margo Chase Design

illustrator Anita Kunz

client/service Atherton/ commercial production company

paper Neenah Classic Crest Recycled Natural White

type Bradley, Latin Wide

colors Four, process

printing Offset lithography

software Adobe Illustrator

concept Designers used the cliché of the "dog and pony show" to express the client's business—producing television commercials—in a humorous way. Circus imagery and display type reminiscent of antique circus posters continue the theme throughout all of the pieces. For added distinction, business cards have a foldover flap and resemble theater programs.

print run 5,000

art director/studio Elena Baca/
Elena Design
designer/studio Elena Baca/
Elena Design
illustrator Elena Baca
client/service Teri Lueders/
copywriter
paper Fox River Confetti
Kaleidoscope
type Hollyweird, Oracle
colors Two, match
printing Offset lithography
software QuarkXPress, Adobe
Illustrator, Adobe Photoshop

concept This design for a free-
lance copywriter ignores typical
copywriter imagery (typewriters,
pens, pencils) for humorous
but meaningful illustrations of
"speeding brains." The cometlike
image and motto ("brainius
speedius maximus") define the
qualities the client wants to
express: her speed, imagination,
originality and creativity.
special production technique To
achieve the full bleed and white
glow around the illustration, the
white Confetti paper was printed
match gold before being made into
envelopes.
budget $3,500
cost $1,000 (design/production);
$2,400 (printing)
print run 1,000 each
(letterhead, business card,
envelope, note card)

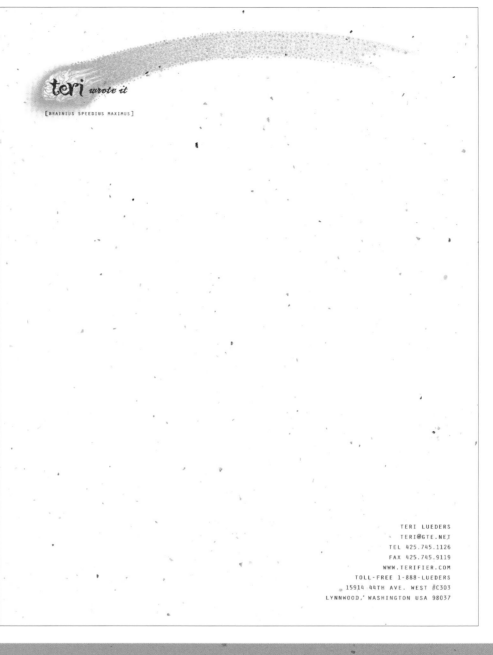

art directors/studio Mark Roberts,
Paul Sessions/Amryliw
designers/studio Mark Roberts,
Paul Sessions/Amryliw
illustrators Mark Roberts,
Paul Sessions
client Self
paper Conqueror CX22 Diamond
type Goudy Sans Medium and
Extra Bold
colors Four, process
printing Offset lithography
software Adobe Illustrator,
Imagination

concept The studio's name, Welsh
for "many-colored," set the tone
for this bright package. Fluid
organic shapes in many colors
express the studio's philosophy
that "colorful stuff makes you
happy." Four different abstract
designs keep the letterhead fresh
and surprising for the recipient.
cost £1,000
print run 500 each
(of four designs)

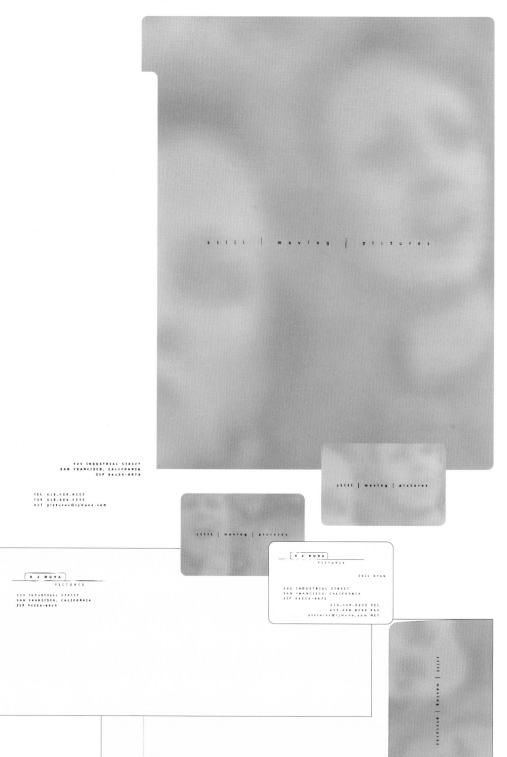

art director/studio Tracy Moon/
AERIAL

designer/studio Tracy Moon/
AERIAL

photographer R.J. Muna Pictures

client/service R.J. Muna
Pictures/photographer

paper Strathmore Natural White
Writing (letterhead), Cover
(business card)

type Officina

colors Three, match plus black

printing Offset lithography

software QuarkXPress

concept This package introduced
the client's new name and empha-
sis on digital, film and video
imagery, as well as traditional
photography. The tag line
"still/moving/pictures" says it in
words, while the diffused images
represent the client's commercial
and fine art styles. All pieces fea-
ture radius corners to give them a
soft look that matched the photos.

special production technique
Radius corners were die cut.

print run 7,500

art director/studio Sondra
Holtzman/Images Graphic
Design & Illustration
client Self
paper Mohawk Softwhite
type Aqualine
printing Laser printing, color
xerography
software QuarkXPress, Adobe
Photoshop

concept This self-produced letter-
head package for a designer/illus-
trator allows her freedom to show-
case her work and style.
cost-saving technique Laser
printing allows the designer to
produce only as many sheets as
she needs, and lets her change
illustrations at will.

special production techniques
The designer personalizes her
business cards by cutting them
with patterned scissors, punching
out numbers and other designs
and gluing on illustrations. She
then laminates 20 at a time.
Laminating preserves the tiny,
two-sided collages and helps her
business card stand out from
others.
cost $85
print run 30

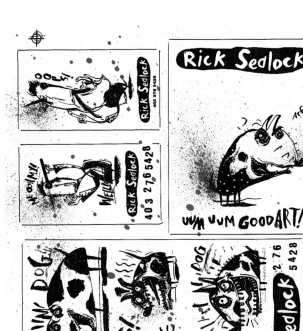

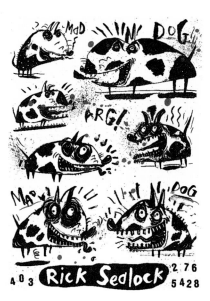

art director/studio Rick
Sealock/Maverick Art Tribe
designer/studio Ken Bessie/
Blackletter Inc.
illustrator Rick Sealock
client/service Rick Sealock
Illustration/illustration
paper Neenah Classic Columns
type Hand-lettering, Clarendon
colors Two, match
printing Offset lithography

concept How can an illustrator
with a distinctive style that can
only be described as "messy and
slightly deranged" use examples
of his work for his letterhead
and convey that his business is
professional? The answer is this
package, complete with faux
splatters of blood and other
unmentionables. A thick, classic
paper stock grounds the piece,
while lots of white space lets the
art speak for itself.

cost-saving technique Two
business cards, a note card and a
postcard were printed on one
sheet.
cost $561
print run 500

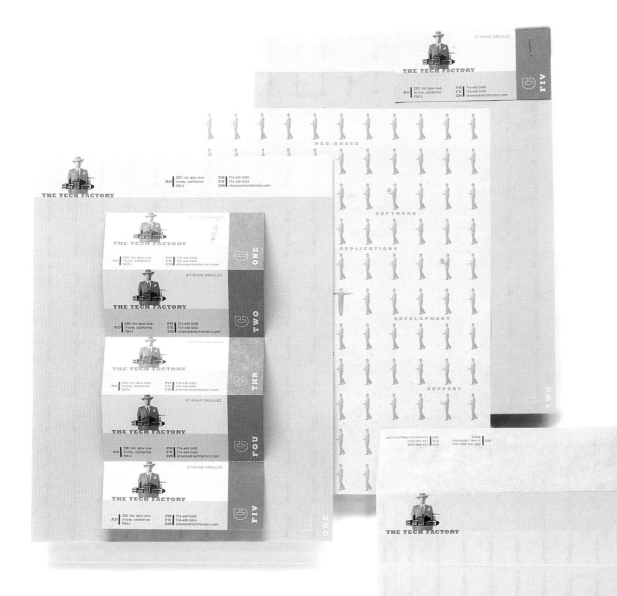

art director/studio Jeff Labbé/
Labbé Design Co.
designer/studio Jeff Labbé/
Labbé Design Co.
illustrator CSA Archive (factory)
photographer Kimball Hall (men)
client/service The Tech
Factory/software applications
development and support
paper French Dur-O-Tone
Butcher Off White Text, Cover;
label stock
type Memphis, Rockwell, Spartan
colors Three, match
(one custom); plus black
printing Offset lithography
software Adobe Illustrator,
QuarkXPress

concept The package is designed
to express the personality of the
client: a small group of confident,
bold, aggressive, and smart people
dedicated to their clients' inter-
ests. Each sheet is backed with a
tiny army of men in suits—a tech
factory.

special production techniques
To get the illustration inside and
the bleed on the flap, the
envelopes were printed before
being assembled. Business cards
were folded and perforated in
groups of five. The design was
inspired by books of war rations.
cost $6,000 (design); $6,000
(printing)
print run 15,000

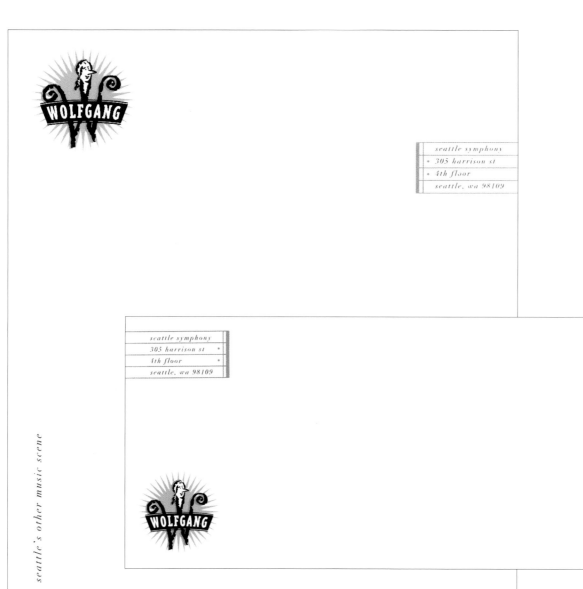

seattle's other music scene

concept This stationery package for Wolfgang, a young professional's organization associated with the Seattle Symphony Orchestra, eschews a "Mozart in sunglasses" look in favor of a looser, but hip, style. The humorous monogram and motto ("Seattle's other music scene") establish a friendly rapport with the recipients. The other design motif, a musical staff holding address information, bleeds off the page to show that music is only half the story of this social club.

cost-saving technique The two-color piece uses screen tints for the appearance of a third color.

print run 1,000

art director/studio Jacki McCarthy/Art O Mat Design

designer/studio Mark Kaufman/Art O Mat Design

illustrator Mark Kaufman

client Seattle Symphony Orchestra

paper Neenah Classic Crest

type Didot

colors Two, match

printing Offset lithography

software Aldus FreeHand

art director/studio John Sayles/
Sayles Graphic Design
designer/studio John Sayles/
Sayles Graphic Design
illustrator John Sayles
client/service Alphabet Soup/
toy store
paper Neenah Environment White
(letterhead and business card),
Williamhouse Teal (envelope),
MacTac (label)
type Arial Rounded, Futura
colors Four, match
printing Offset lithography
software QuarkXPress

concept A different but related
design for each piece keeps this
package lively and fits the client's
business—having fun. The busi-
ness card is die cut in the shape
of a waving banner, an image that
appears on each piece.
cost-saving techniques Although
the pieces all have different
designs, using the same colors
throughout allowed them to be
printed at once and lowered the
cost. Even with a label that covers
most of its surface, the 6″ x 9″
envelope costs the same to mail as
a common no. 10, but has far
greater impact. And the label can
also be used for boxes.
special production technique
The two-sided, die-cut business
card shows employee names on
the front and store locations on
the back.
print run 3,000

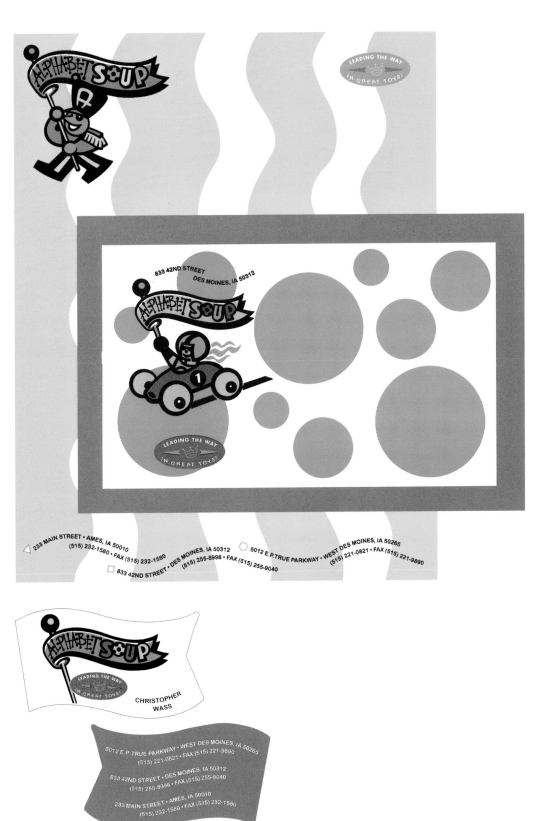

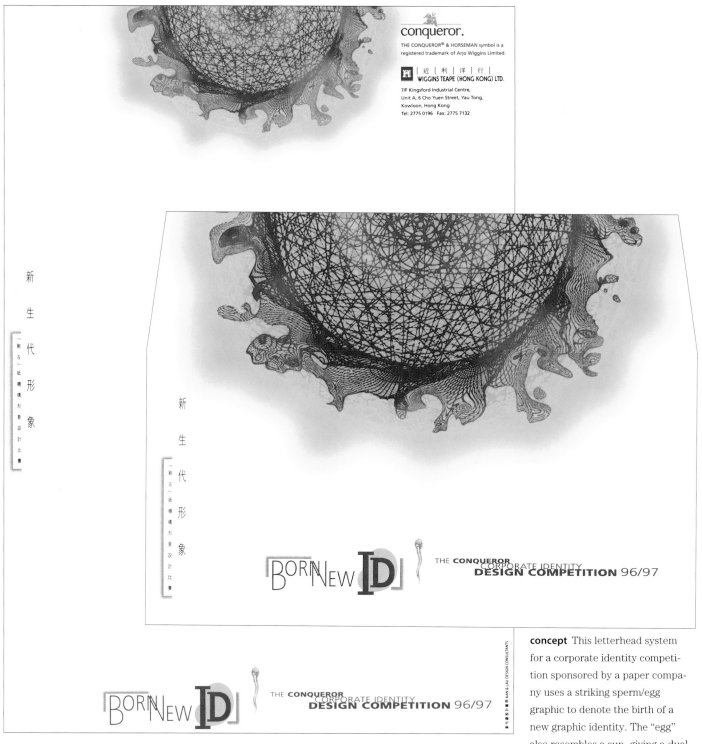

concept This letterhead system for a corporate identity competition sponsored by a paper company uses a striking sperm/egg graphic to denote the birth of a new graphic identity. The "egg" also resembles a sun, giving a dual meaning to the image.

special production technique The yellow and magenta inks were specially mixed to make them brighter.

art director/studio Freeman Lau Siu Hong/Kan & Lau Design Consultants

designers/studio Freeman Lau Siu Hong, Stephen Lau Yu Cheong/Kan & Lau Design Consultants

computer illustrator Benson Kwun Tin Yau

client/service Wiggins Teape, Ltd./paper stock dealer

paper Contour Brilliant White

colors Four, process

printing Offset lithography

software Live Picture, Adobe Photoshop, Aldus FreeHand

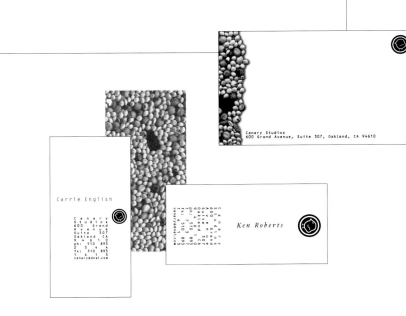

art directors/studio Ken Roberts, Carrie English/Canary Studios

designers/studio Ken Roberts, Carrie English/Canary Studios

illustrator Ken Roberts

client Self

paper Fox River Confetti White (letterhead and business cards), silver antistatic bags (envelopes)

type OCR-A (text), Minion Italic, Letter Gothic (names)

colors Four, process over one, match

printing Offset lithography

software QuarkXPress, Adobe Illustrator, Adobe Photoshop

concept This distinctive letterhead for a graphic design firm communicates the company name before a client opens the envelope. Letterhead and business cards look simple from the front—black print on white paper—but the backs are printed with a four-color image of bird seed. Folded in half and mailed reverse-side out in transparent envelopes, they stand out from other letters.

cost-saving technique Prepress was done in-house.

special production technique Instead of using a stock or custom photograph of bird seed, the designers arranged bird seed on their scanner and scanned it.

cost $1,950

print run 1,000

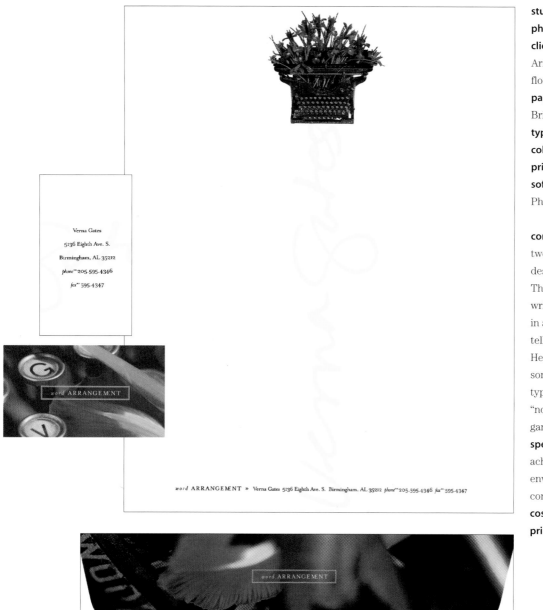

studio FitzMartin

photographer Andrew Massey

client/service Verna Gates, Word Arrangements/copywriting and floral folklore

paper Neenah Classic Crest, Avon Brilliant White

type Mrs. Eaves roman and italic

colors Four, process

printing Offset lithography

software QuarkXPress, Adobe Photoshop

concept The client, who works in two very different fields, needed a design that would combine both. The photo of an antique type-writer filled with flowers explains, in a single image, that the client tells stories in words or flowers. Her flowing signature adds a personal touch, while the use of a type dingbat and the superscript "no." gives the type a formal elegance rarely seen.

special production technique To achieve the full bleed on the flaps, envelopes were printed before conversion.

cost $5,000

print run 2,000

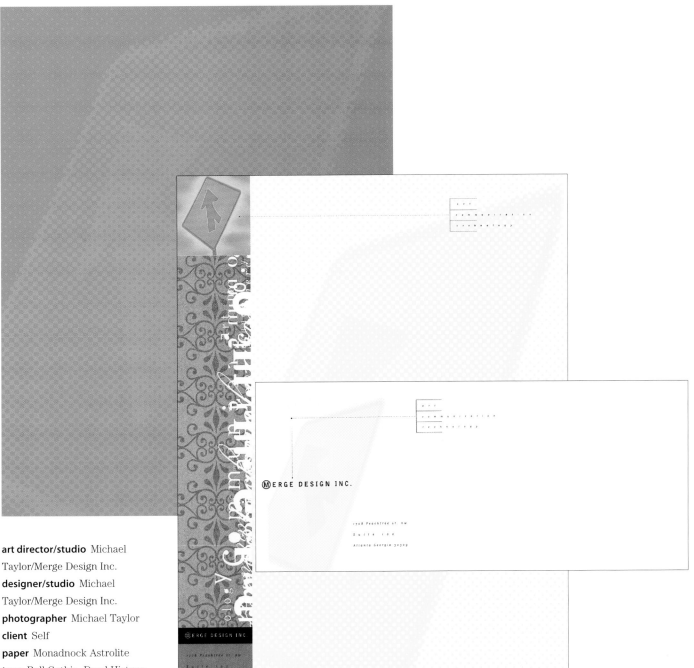

art director/studio Michael
Taylor/Merge Design Inc.
designer/studio Michael
Taylor/Merge Design Inc.
photographer Michael Taylor
client Self
paper Monadnock Astrolite
type Bell Gothic, Dead History,
Democratica
colors Four, match
printing Offset lithography
software QuarkXPress, Adobe
Photoshop

concept The package is meant
to convey the design "edge" the
multidisciplinary firm brings to its
projects. The photo, repeated in a
yellow dot screen on the envelope
and the stationery writing space,
graphically portrays the firm's
name. The type treatment
addresses both the technological
and artistic sides of the firm's
business.

cost-saving technique The
designer took the photo himself.
special production technique
Black was dry-trapped over solid
green to bring out the subtle
screens.
cost $3,000
print run 3,000

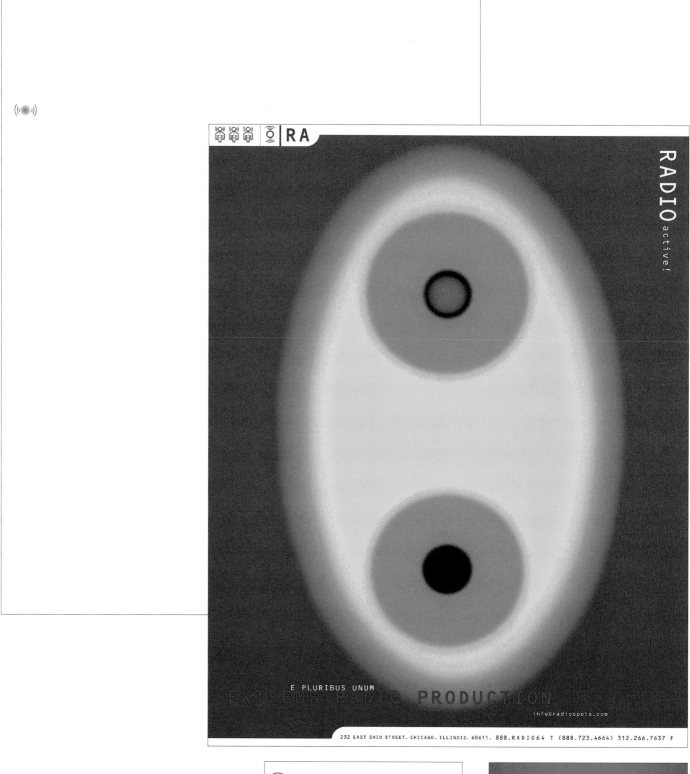

art director/studio Carlos Segura/
Segura Inc.
designer/studio Carlos Segura/
Segura Inc.
illustrator Carlos Segura
photographer Photonica
client/service Radio Active!/radio
production company
colors Four, process
printing Offset lithography
software Adobe Illustrator,
Adobe Photoshop

concept The tone for this package
is replete with circular shapes and
aggressive "atomic" imagery.
Saturated colors and a strong
graphic emphasis on the logo and
name help this letterhead stand
out, as does a side-opening
envelope.
print run 10,000

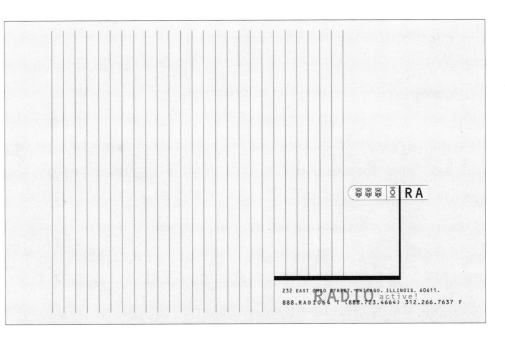

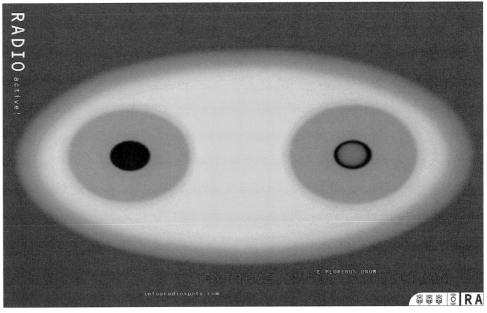

art director/studio Tom Maciag/Dyad Communications
designer/studio Tom Maciag/Dyad Communications
photographer Dominic Episcopo
client/service Dominic Episcopo/photography
paper Strathmore Elements Bright White Dots
type Trixie, Bodoni
colors Two, match
printing Offset lithography
software QuarkXPress

concept Patterned paper adds another layer to the layered design, which emphasizes unusually shaped and placed blocks of type. Ghosted imagery explains the client's business—photography—without showing specific subjects or styles.
cost $4,000 (including design)
print run 1,500

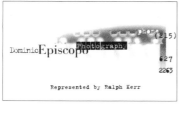

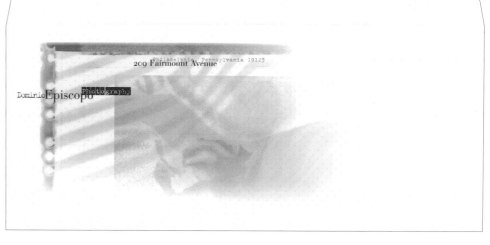

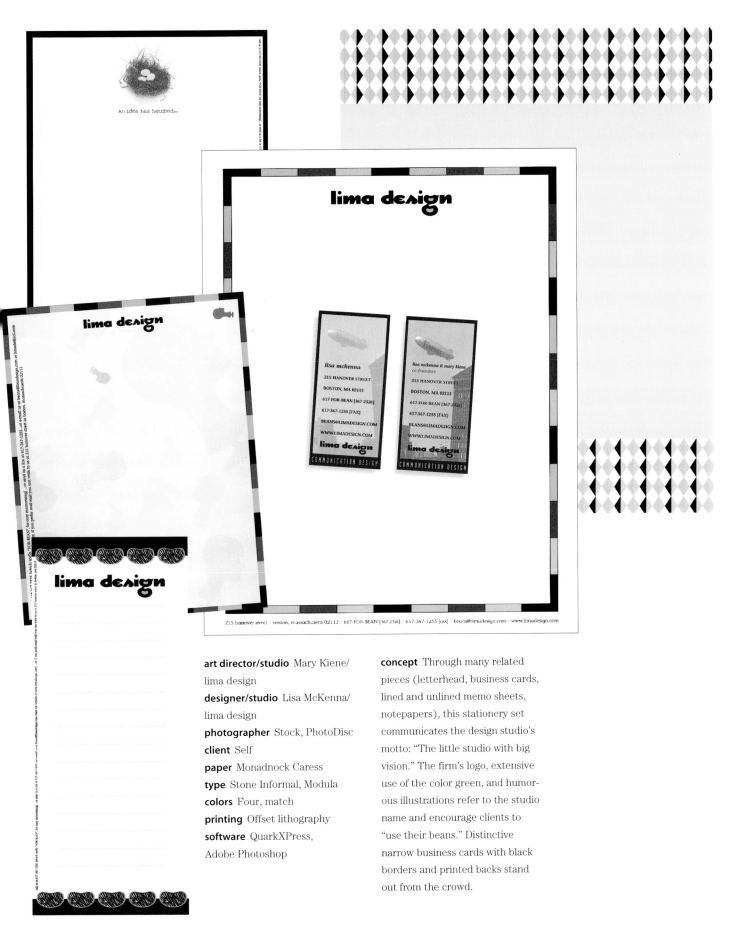

art director/studio Mary Kiene/
lima design

designer/studio Lisa McKenna/
lima design

photographer Stock, PhotoDisc

client Self

paper Monadnock Caress

type Stone Informal, Modula

colors Four, match

printing Offset lithography

software QuarkXPress,
Adobe Photoshop

concept Through many related
pieces (letterhead, business cards,
lined and unlined memo sheets,
notepapers), this stationery set
communicates the design studio's
motto: "The little studio with big
vision." The firm's logo, extensive
use of the color green, and humor-
ous illustrations refer to the studio
name and encourage clients to
"use their beans." Distinctive
narrow business cards with black
borders and printed backs stand
out from the crowd.

art director/studio Kan Tai-keung/
Kan & Lau Design Consultants
designer/studio Kan Tai-keung/
Kan & Lau Design Consultants
photographer C.K. Wong
client Kan Tai-keung
paper Conqueror Diamond White
CX22 (letterhead and business
card), Conqueror Highwhite Wove
(envelope)
colors Four, process plus two,
match
printing Offset lithography
software Adobe Photoshop, Aldus
FreeHand

concept The designer's personal
stationery features traditional
calligraphy tools and flowing
brush marks. Chinese characters
and English letters are balanced
harmoniously on all pieces.
special production techniques
The photographs and brush-
strokes are printed four-color
process. The designer's name (in
Chinese characters) is printed in a
spot color to make it stand out.

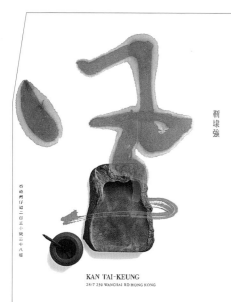

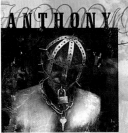

art director/studio
Steven R. Gilmore/
SRG Design
designer/studio
Steven R. Gilmore/
SRG Design
photographers Anthony Artiaga
(main image), Steven R. Gilmore
(background)
client/service Anthony Artiaga/
photographer
paper Printer's stock
type Hand-lettering, Bodoni,
Schadow Antiqua Bold
Condensed, Viant
colors Four, process
printing Offset lithography
software Macromedia FreeHand,
Adobe Photoshop

concept An arresting combination
of beautiful and disturbing images,
this business card draws attention
to the client's photography and
alerts potential clients to his
unusual style. A less shocking but
ambiguous image is ghosted on
the opposite side.
print run 1,500

art director/studio Steven R.
Gilmore/SRG Design
designer/studio Steven R.
Gilmore/SRG Design
illustrator Steven R. Gilmore
client/service Marcus
Gilmore/club disc jockey and
musician
paper Printer's stock
type Cosmos Bold
colors Four,
process
printing Offset
lithography
software
Macromedia
FreeHand, Adobe
Photoshop

concept The cen-
tral figure, an
unapologetic cari-
cature, suits the
hip-hop music the
client plays and
performs. The green bull's-eye
pattern, repeated on the back,
recalls record grooves and sound
waves. A rippled-water back-
ground repeats the theme.
print run 2,000

art director/studio Steven R.
Gilmore/SRG Design
designer/studio Steven R.
Gilmore/SRG Design
client/service Sparks WWW
Design/Web site design
paper Printer's stock
type Bell Gothic
colors Four, process
printing Offset lithography
software Macromedia FreeHand,
Adobe Photoshop

concept A visual pun, this card
uses brilliant reds and blurred
halos to suggest matches, flames,
heat and sparks. On the reverse,
black type printed over a full-
bleed beige background and the
ghosted word "work" explains the
firm's expertise.
print run 2,000

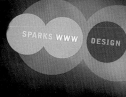

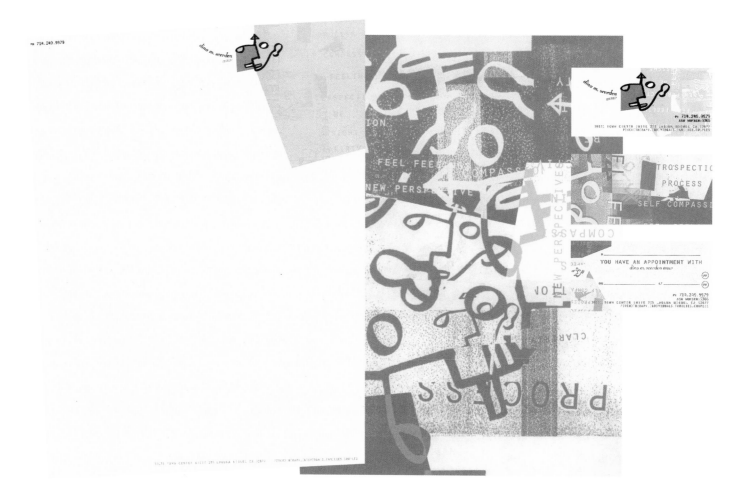

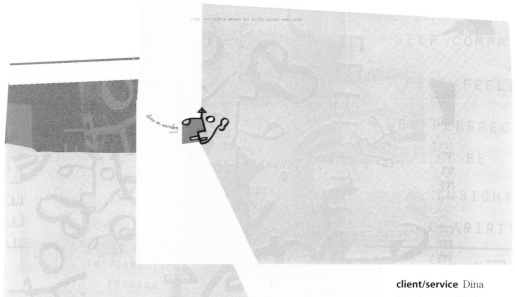

type Orator, Berkley Italic
colors Two, match
printing Offset lithography
software Adobe Illustrator, QuarkXPress

concept The logo represents the client's business: helping people feel better. Two faces, one talking and one listening, are joined together. An arrow points up, a positive direction.
cost-saving techniques The design was a gift. The pieces were printed on paper left over from other jobs.
special production techniques All business cards and appointment cards fit together, making a puzzle. The letterhead and envelope flaps were angle-trimmed for a subtle effect.
cost $4,000
print run 5,000

art director/studio Jeff Labbé/ Labbé Design Co.
designer/studio Jeff Labbé/ Labbé Design Co.
illustrator Jeff Labbé

client/service Dina Seerden, M.S.W./ psychologist
paper French Dur-O-Tone Butcher Off White Text, Cover; Newsprint Extra White Text, Cover; Newsprint Aged Text, Cover

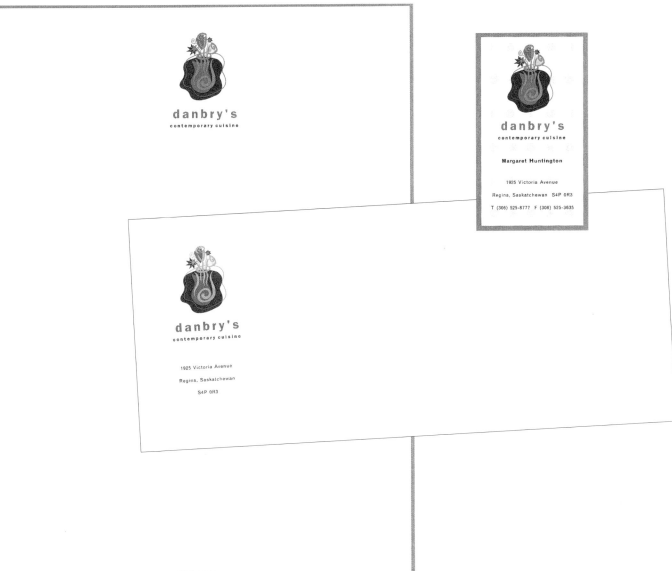

art director/studio Catharine Bradbury/Bradbury Design Inc.
designer/studio Catharine Bradbury/Bradbury Design Inc.
illustrator Catharine Bradbury
client/service Danbry's Contemporary Cuisine/restaurant
paper Beckett Expression Writing, Cover; Iceberg
type Franklin Demi, Groschen Bold, Groschen
colors Three, match (one metallic)
printing Offset lithography

software QuarkXPress, Adobe Illustrator

concept The designer was called in after the restaurant's interior design was completed. For the restaurant's identity, she featured three elements used in the interior design so that the identity looked as if it came first.
print run 1,000 (letterhead); 250 each (cards, of ten names); 2,000 (envelopes)

Judy Bertz

Ted Bertz Graphic Design

190 Washington Street
Middletown, Connecticut 06457

Phone: 860·347·4332
Fax: 860·346·6851
Email: bertz@tiac.net

Susan Glueck

Ted Bertz Graphic Design

190 Washington Street
Middletown, Connecticut 06457

Phone: 860·347·4332
Fax: 860·346·6851
Email: bertz@tiac.net

Ted Bertz

Ted Bertz Graphic Design

190 Washington Street
Middletown, Connecticut 06457

Phone: 860·347·4332
Fax: 860·346·6851
Email: bertz@tiac.net

14300 Hickory Links Court Unit 1816
Fort Meyers, Florida 33912

Phone: 941·561·3720
Fax: 941·561·1910

Katie Kesten

Ted Bertz Graphic Design

190 Washington Street
Middletown, Connecticut 06457

Phone: 860·347·4332
Fax: 860·346·6851
Email: bertz@tiac.net

Dawn Droskoski

Ted Bertz Graphic Design

190 Washington Street
Middletown, Connecticut 06457

Phone: 860·347·4332
Fax: 860·346·6851
Email: bertz@tiac.net

Mark Terranova

Ted Bertz Graphic Design

190 Washington Street
Middletown, Connecticut 06457

Richard Uccello

Ted Bertz Graphic Design

190 Washington Street
Middletown, Connecticut 06457

Phone: 860·347·4332
Fax: 860·346·6851
Email: bertz@tiac.net

Andrew Wessels

Ted Bertz Graphic Design

190 Washington Street
Middletown, Connecticut 06457

Phone: 860·347·4332
Fax: 860·346·6851
Email: bertz@tiac.net

art directors/studio Ted Bertz, Richard Uccello/Ted Bertz Graphic Design, Inc.
designer/studio Mark Terranova/Ted Bertz Graphic Design, Inc.
photographers Paul Horton (pencil, pen, paint tube, computer cord), stock from CD (paper clip, telephone, basket of flowers, lightbulb)
client Self
paper Monadnock Astrolite
type Bodoni Book (main), Franklin Gothic Bold (employee names)
colors Four, process
software QuarkXPress, Adobe Photoshop

concept Cards depict a variety of objects related to graphic design or business. Drop shadows give the photos a three-dimensional look.
cost $4,000 (printing); $500 (photography)
print run 500 sheets

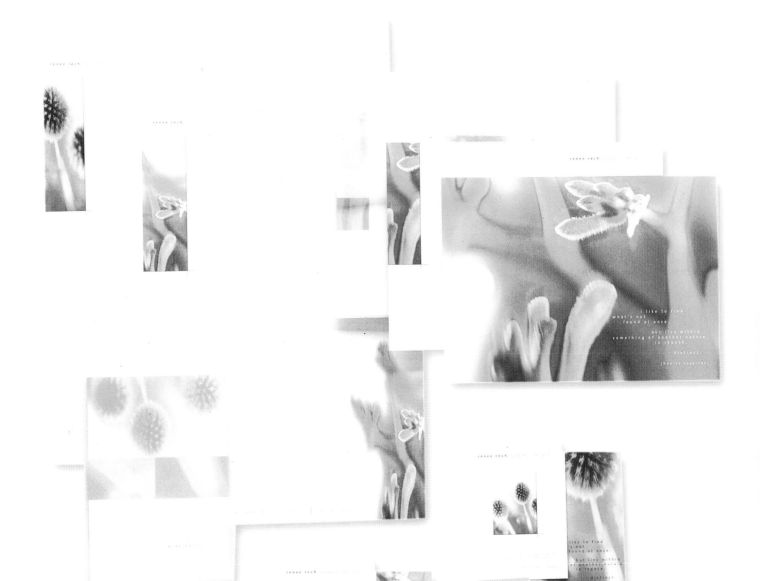

art director/studio Renée Rech/
Renée Rech Design

designer/studio Renée Rech/
Renée Rech Design

illustrator Renée Rech

photographer Stock from CD

client Self

paper Gilbert ESSE Texture
White Writing (letterhead),
Consolidated Productolith Dull

type The Sans and Gill Sans

colors Four, process; pearlescent
varnish on all pieces but letter-
head

printing Offset lithography

software QuarkXPress,
Adobe Photoshop

concept The
designer's goal was to create
a letterhead package that would
be both personal and professional.
She combined stock photographs
and favorite quotations that she
hoped would provoke thought as
well as an emotional reaction. The
design used on the oversized busi-
ness cards also appeared on note
cards and gift booklets, all mailed
in vellum envelopes to reveal their
contents.

cost-saving technique Some of
the pieces were printed with other
jobs.

special production technique All
pieces but the letterhead are spot-
printed with a pearlescent varnish.
When held up to a light, they
reveal the quotation printed in
larger letters.

cost $1,000 plus design services

print run 3,000

art directors/studio John Swieter, Mark Ford/Swieter Design U.S.
designers/studio John Swieter, Mark Ford/Swieter Design U.S.
client/service Ignition/industrial design
paper Fox River Starwhite Vicksburg, MacTac (labels)
type Geometric
colors Two, match
printing Offset lithography
software Adobe Illustrator

concept The bright orange color and distinctively shaped pieces set this package apart from the rest. The label, a combination "i" and lightning bolt, is applied to everything, including videotape labels and custom lightning bolt stickers.
special production technique Letterhead, business cards and envelopes were cut with custom dies.
print run 10,000

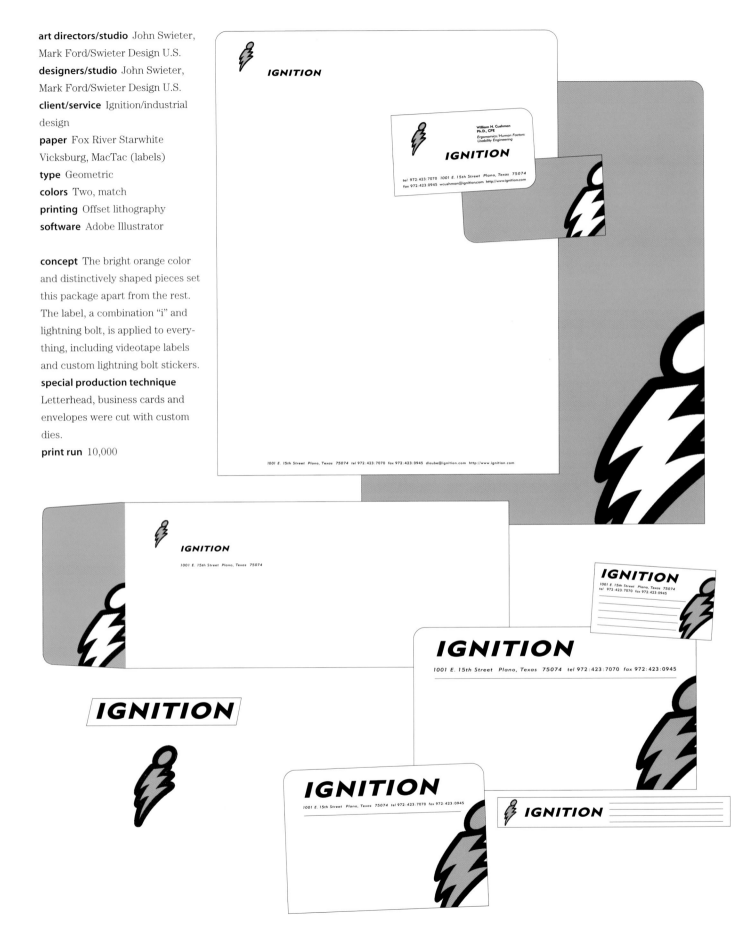

designers/studio Penina A. Goodman, Michelle S. Goldish/Oxygen, Inc.
client/service Ucopia/wedding registry
paper Fox River Starwhite Vicksburg Tiara Smooth Text (letterhead), Cover (business cards)
type Tophat
colors Two, match plus black
printing Offset lithography
software Aldus FreeHand

concept For a "breakthrough concept" in wedding registry, designers created a bold image using bright colors. Nothing like traditional wedding business design, which usually features flowers, ribbons and cupids, this package stands out from competitors and appeals to men as well as women.
cost $3,500 (including two versions each of letterhead, second sheets, envelopes, acknowledgment cards and envelopes, and mailing labels, as well as four versions of business cards)
print run 3,000 (letterhead); 500 each (of three business card designs); 1,500 (of fourth business card design); 2,000 (envelopes)

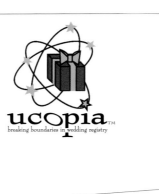

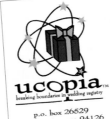

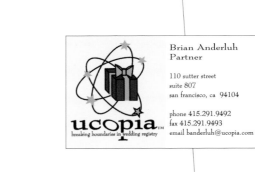

art director/studio Mike Salisbury/
Mike Salisbury Communications,
Inc.
designer/studio Mary Evelyn
McGough/Mike Salisbury
Communications, Inc.
photographer Aaron Chang
client/service *Rage Magazine/*
men's magazine
paper Neenah Environment
type Platelet Gothic, Emigre
colors Four, process plus one
match fluorescent
printing Offset lithography
software Adobe PageMaker

concept Modern type and layout
create something that's "not your
father's letterhead." A deliberately
provocative photograph matches
the magazine's name and tells
potential subscribers and advertis-
ers what it's all about. The model's
image is used on all of the pieces
except the letterhead sheet itself,
where perhaps it would prove too
distracting. Fluorescent green ink,
printed as a full bleed, makes the
business card and mailing label
even more noticeable.
cost Part of a $150,000 total
magazine design
print run 5,000

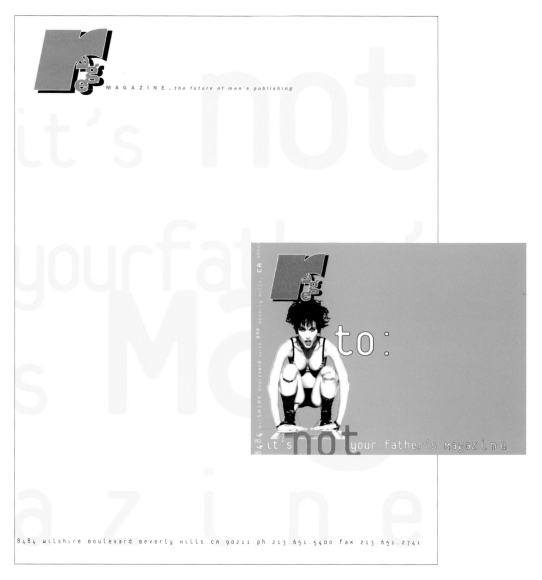

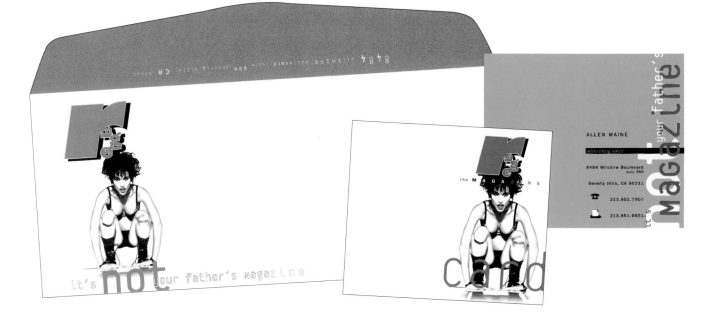

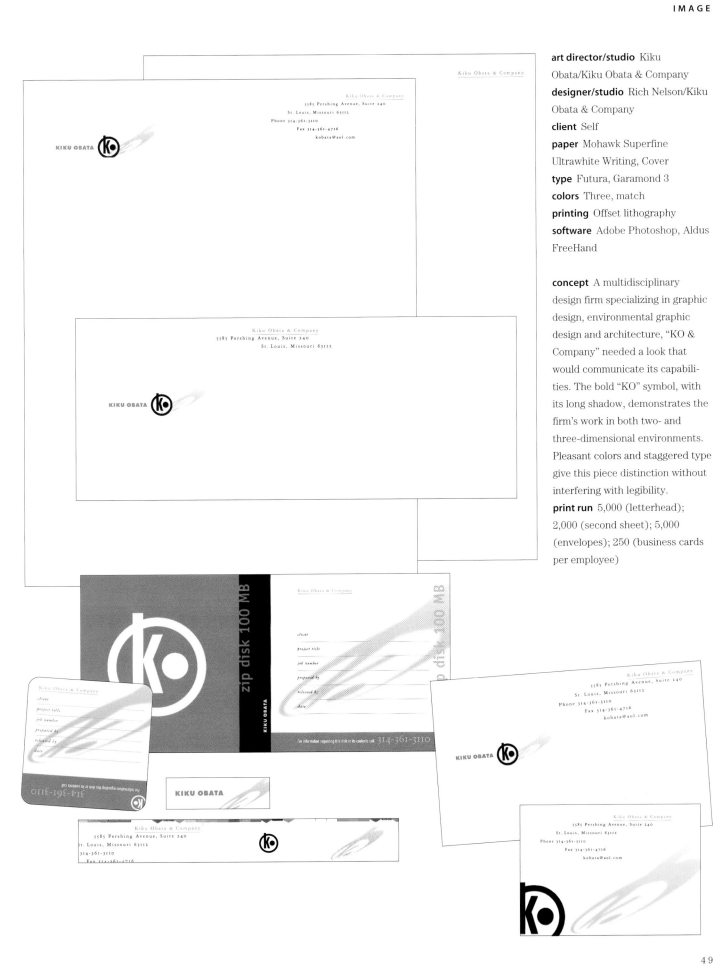

art director/studio Kiku Obata/Kiku Obata & Company
designer/studio Rich Nelson/Kiku Obata & Company
client Self
paper Mohawk Superfine Ultrawhite Writing, Cover
type Futura, Garamond 3
colors Three, match
printing Offset lithography
software Adobe Photoshop, Aldus FreeHand

concept A multidisciplinary design firm specializing in graphic design, environmental graphic design and architecture, "KO & Company" needed a look that would communicate its capabilities. The bold "KO" symbol, with its long shadow, demonstrates the firm's work in both two- and three-dimensional environments. Pleasant colors and staggered type give this piece distinction without interfering with legibility.
print run 5,000 (letterhead); 2,000 (second sheet); 5,000 (envelopes); 250 (business cards per employee)

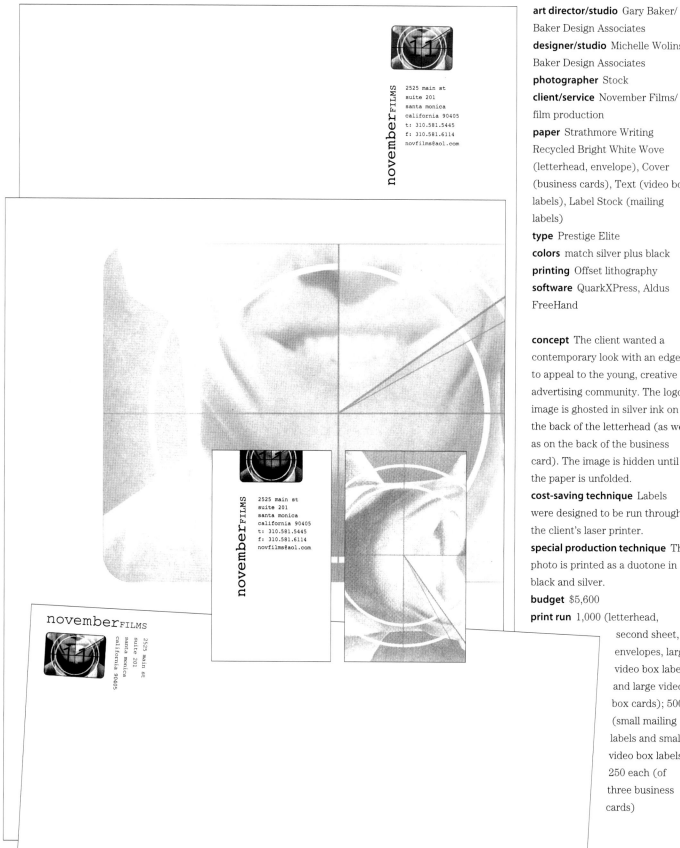

art director/studio Gary Baker/
Baker Design Associates
designer/studio Michelle Wolins/
Baker Design Associates
photographer Stock
client/service November Films/
film production
paper Strathmore Writing
Recycled Bright White Wove
(letterhead, envelope), Cover
(business cards), Text (video box
labels), Label Stock (mailing
labels)
type Prestige Elite
colors match silver plus black
printing Offset lithography
software QuarkXPress, Aldus
FreeHand

concept The client wanted a
contemporary look with an edge
to appeal to the young, creative
advertising community. The logo
image is ghosted in silver ink on
the back of the letterhead (as well
as on the back of the business
card). The image is hidden until
the paper is unfolded.
cost-saving technique Labels
were designed to be run through
the client's laser printer.
special production technique The
photo is printed as a duotone in
black and silver.
budget $5,600
print run 1,000 (letterhead,
second sheet,
envelopes, large
video box labels
and large video
box cards); 500
(small mailing
labels and small
video box labels);
250 each (of
three business
cards)

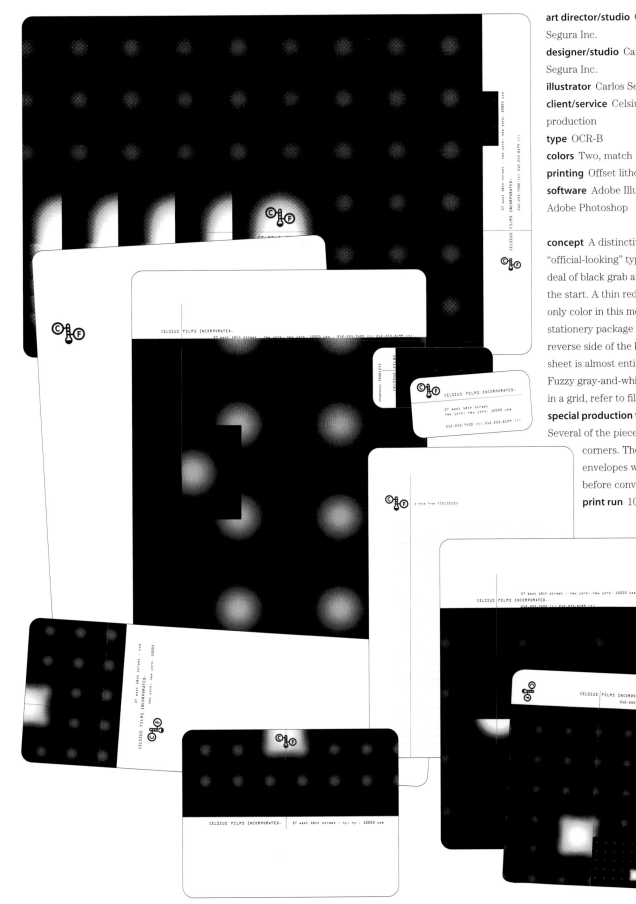

art director/studio Carlos Segura/
Segura Inc.
designer/studio Carlos Segura/
Segura Inc.
illustrator Carlos Segura
client/service Celsius Films/film
production
type OCR-B
colors Two, match
printing Offset lithography
software Adobe Illustrator,
Adobe Photoshop

concept A distinctive logo,
"official-looking" type and a great
deal of black grab attention from
the start. A thin red line is the
only color in this mostly black
stationery package (even the
reverse side of the letterhead
sheet is almost entirely black).
Fuzzy gray-and-white shapes, set
in a grid, refer to film spotlights.
special production techniques
Several of the pieces have die-cut
corners. The side-opening
envelopes were printed
before conversion.
print run 10,000

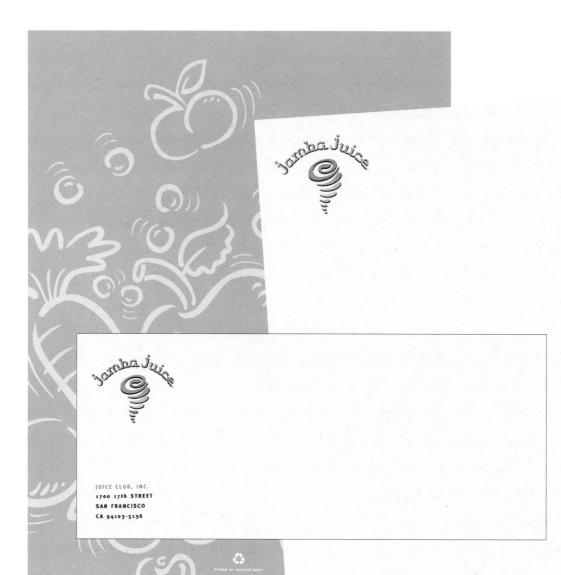

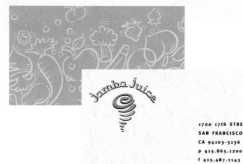

art director/studio Jack Anderson/
Hornall Anderson Design Works,
Inc.

designers/studio Jack Anderson,
Lisa Cerveny, Suzanne Haddon/
Hornall Anderson Design Works,
Inc.

illustrator Mits Katayama

client/service Jamba Juice/fresh
fruit juices and smoothies

paper Fox River Sundance

type Meta, Bembo

colors Four, process

printing Offset lithography

software Aldus FreeHand,
QuarkXPress

concept Part
of a corporate
identity pro-
gram, this pack-
age was designed
to present the company as fun and
festive but not too trendy, and to
appeal to people of all ages. The
simple stationery emphasizes the
colorful logo.

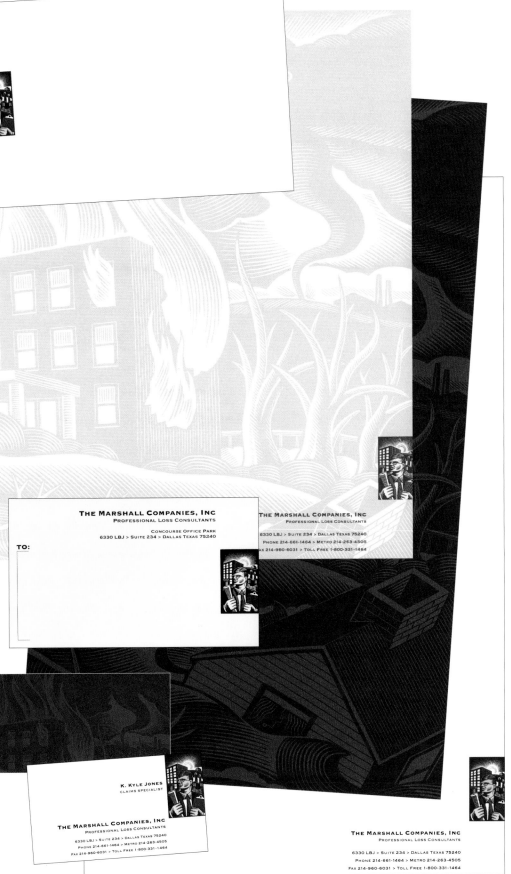

art director/studio John Swieter/
Swieter Design U.S.

designers/studio John Swieter,
Kevin Flatt/Swieter Design U.S.

illustrator Chris Gall

client/service The Marshall
Companies/insurance adjusters

paper Fox River Starwhite
Vicksburg

type Copperplate

colors Four, process plus two,
match; varnish

printing Offset lithography

software Adobe Illustrator

concept Part of a comprehensive
corporate identity program aimed
at elevating the client's reputation
in their industry and making them
more familiar to customers, this
package looks both expensive and
confident. All pieces show the
illustration of a heroic insurance
adjuster in the bright sunshine.
The letterhead sheet also shows
the problems he is called upon to
solve: flood damage, fire damage,
even a house whirling into the air
in a tornado. The back sides of
legal-sized sheets include a larger
version of that image, while the
backs of business cards show a
detail.

special production techniques All
pieces are printed as full bleeds.
Pieces printed on the back are
also sealed with a dull varnish.

print run 10,000

design team/studio Jonathan Amen, David Collins, Judy Kirpich/Grafik Communications, Ltd.

client Major League Soccer Players Association

paper Strathmore 25% Cotton (stationery)

type Armada

colors Two, match (letterhead)

printing Offset lithography

software Aldus FreeHand, QuarkXPress

concept The dynamic illustration and bright orange-yellow make this two-color piece vibrant.

cost-saving techniques The client wanted color and verve, but had a limited budget and could not afford more than two colors on the letterhead. Designers added color by designing a four-color sticker that could be printed with the two-color mailing label.

cost $6,162 (printing)

print run 1,000 (business cards); 2,500 (mailing labels); 5,000 (letterhead); 5,000 (envelopes)

art director/studio Richard Kilmer/Kilmer & Kilmer

designer/studio Randall Marshall/Kilmer & Kilmer

client/service International Family Film Festival/film festival about family issues

paper Fox River Starwhite Vicksburg

type Univers

colors Three, match over one, match

printing Offset

software Adobe Illustrator, QuarkXPress

concept For the inauguration of this festival, the designer felt a strong image was needed. The playful logo consists of objects—movie reels, a camera and a film-strip—that form a face. The bold colors of this package set it apart and enhance the fun mood.

cost-saving technique The printing, paper and design were donated.

cost $0

print run 2,500

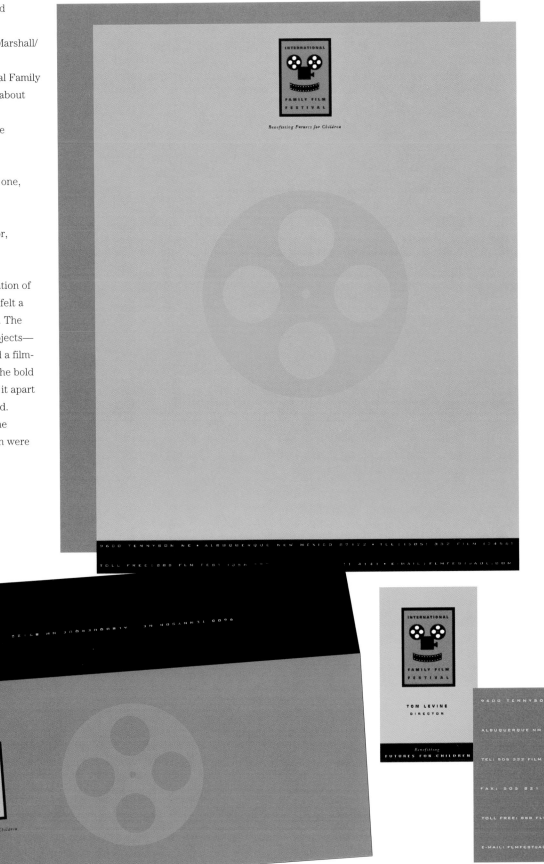

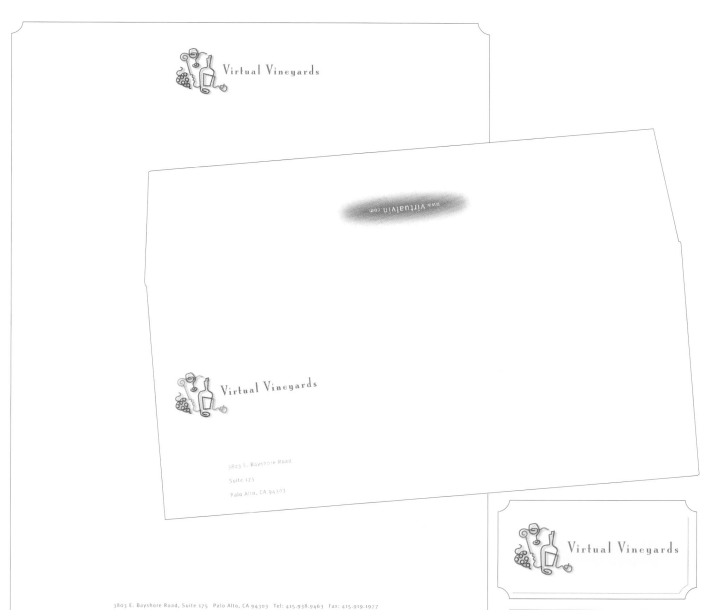

art directors/studio Earl Gee, Fani Chung/Gee + Chung Design
designers/studio Earl Gee, Fani Chung/Gee + Chung Design
illustrator Earl Gee
client/service Virtual Vineyards/ Internet wine seller
paper Strathmore Writing Ultimate White Wove (letterhead and envelope), Cover (business card)

type Mona Lisa (logo), Meta Plus Book (text)
colors Two, match (letterhead); three, match (business card)
printing Offset lithography
software QuarkXPress, Adobe Illustrator, Adobe Photoshop

concept Aged wine and modern technology meet in the design of this letter-head package for a wine vendor who markets exclusively on the Internet. A jazzy illustration depicts every aspect of wine making (in blue) and a face and computer mouse (in brown). A computer-produced drop shadow (a screen of the match brown) on all pieces and a soft yellow blur on one side of the business card help create a classic, old-world look.

special production technique Die-cut corners on the stationery and business cards imitate wine labels.
print run 5,000

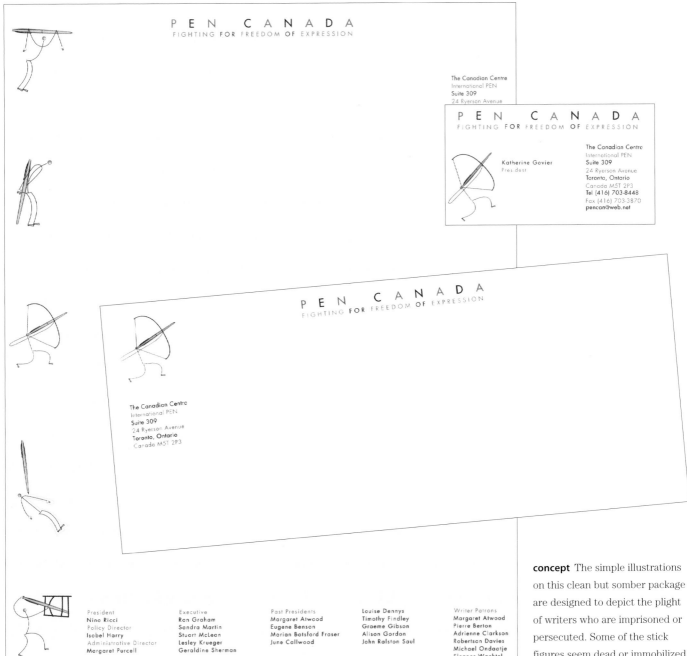

PEN CANADA
FIGHTING FOR FREEDOM OF EXPRESSION

The Canadian Centre
International PEN
Suite 309
24 Ryerson Avenue

PEN CANADA
FIGHTING FOR FREEDOM OF EXPRESSION

Katherine Govier
President

The Canadian Centre
International PEN
Suite 309
24 Ryerson Avenue
Toronto, Ontario
Canada M5T 2P3
Tel (416) 703-8448
Fax (416) 703-3870
pencan@web.net

PEN CANADA
FIGHTING FOR FREEDOM OF EXPRESSION

The Canadian Centre
International PEN
Suite 309
24 Ryerson Avenue
Toronto, Ontario
Canada M5T 2P3

President
Nino Ricci
Policy Director
Isobel Harry
Administrative Director
Margaret Purcell

Executive
Ron Graham
Sandra Martin
Stuart McLean
Lesley Krueger
Geraldine Sherman

Past Presidents
Margaret Atwood
Eugene Benson
Marian Botsford Fraser
June Callwood

Louise Dennys
Timothy Findley
Graeme Gibson
Alison Gordon
John Ralston Saul

Writer Patrons
Margaret Atwood
Pierre Berton
Adrienne Clarkson
Robertson Davies
Michael Ondaatje
Eleanor Wachtel

art director/studio Frank Viva/ Viva Dolan Communications and Design, Inc.
designer/studio Frank Viva/Viva Dolan Communications and Design, Inc.
illustrator Frank Viva

client/service Pen Canada/non-profit organization dedicated to helping imprisoned or persecuted writers
paper Conqueror High White Wove
colors One, match plus black
printing Offset lithography
software QuarkXPress, Adobe Illustrator

concept The simple illustrations on this clean but somber package are designed to depict the plight of writers who are imprisoned or persecuted. Some of the stick figures seem dead or immobilized, while others continue to fight with their pens. One of the latter, a dynamic archer, appears on the envelopes and business cards.
cost-saving technique Design and paper were donated.
cost $1,500 (printing)
print run 3,000

art director/studio Douglas May/
May & Co.
designer/studio Jeff Savage/
May & Co.
client/service Texas World
Television/video production
company
paper Fox River Starwhite
Vicksburg
type Avenir
colors Eight, match
printing Offset lithography
software QuarkXPress

concept Bright white paper and
a striped bar reminiscent of a tele-
vision test pattern give distinction
to this simple system. Repeating
the bar on the envelope, where it
appears on both sides, helps
ensure that it will be easy to dis-
tinguish from other mail.
special production technique
Envelopes were printed before
conversion.
print run 5,000

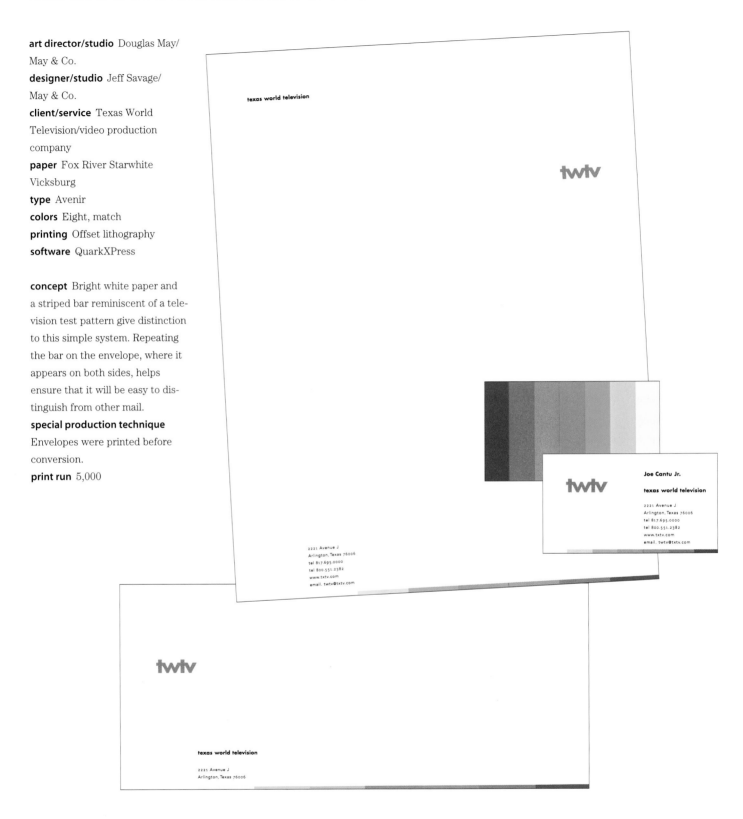

art directors/studio Perry Chua, Dann Ilicic/Big Eye Creative, Inc.

designers/studio Perry Chua, Dann Ilicic/Big Eye Creative, Inc.

photographer/digital imager Grant Waddell

client Self

paper Strathmore Writing Wove (letterhead and envelope), Potlatch McCoy Velvet (business card)

type Bank Gothic, Sabon (logo); Candida (copy)

colors Four, process plus black and varnish (card backs); one, match metallic plus black (others)

printing Offset lithography

software Adobe Illustrator, Adobe Photoshop, QuarkXPress

concept The package was designed for maximum impact with primary emphasis on the business cards as a marketing tool. The firm's main goal was to make clients and potential clients say, "Wow!"

cost-saving techniques This project was done in exchange for designing a new corporate identity for the printer.

special production techniques The backs of the business cards were printed with a double hit of black and a flood gloss varnish, as well as four-color process. All other pieces were printed with a match metallic plus black, including the backs of the letterhead, which were printed with a solid flood of metallic blue and reversed-out type. Envelopes were printed before conversion.

cost $12,000 (Canadian; design and production); $7,000 (Canadian; printing)

print run 1,000

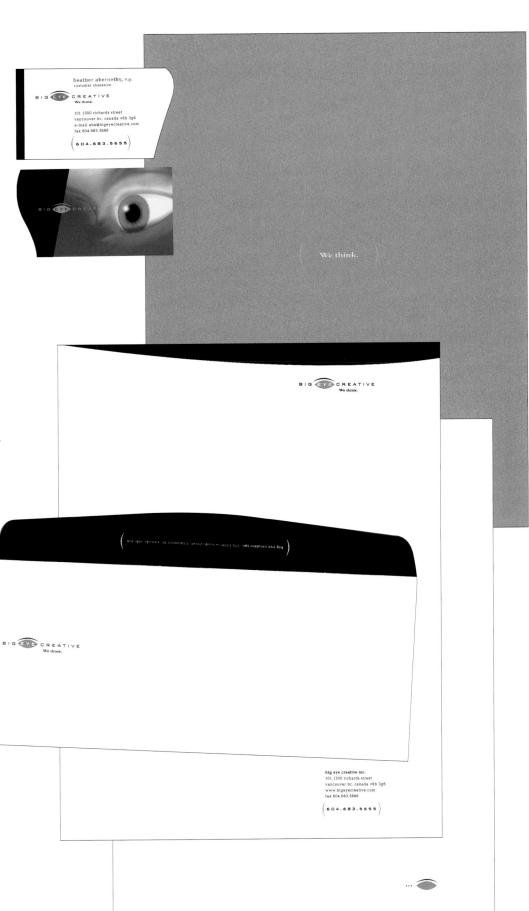

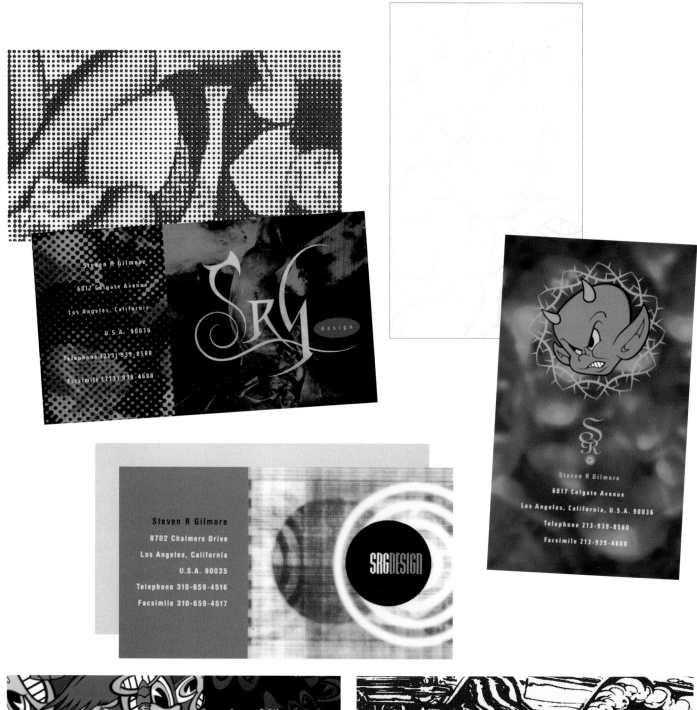

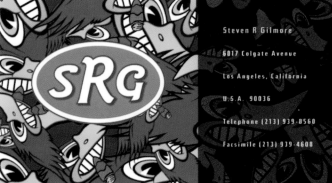

art director/studio Steven R. Gilmore/SRG Design

designer/studio Steven R. Gilmore/SRG Design

illustrator Steven R. Gilmore

photographers Steven R. Gilmore, Anthony Artiaga (racing car card), found images

client Self

paper Printer's stock

type Hand-lettering, Bauer Topic, Typo Upright, Futura, Bell Gothic, Trade Gothic, Helvetica Rounded Condensed

colors Four, process

printing Offset lithography

software Macromedia FreeHand, Adobe Photoshop

concept The designer uses a number of different business cards for self-promotion. The looks are all different, ranging from somewhat sinister photos to abstract shapes with forays into cartoons, but each shows his distinct style. Although much of the imagery and hand-lettering has a dark "gothic" sensibility common to many amateur designers, the precise layering and clear type treatments demonstrate his professionalism. All cards are printed on both sides.

cost-saving technique All cards are printed on whatever the printer had available.

print run 1,000–2,000

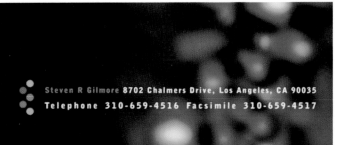

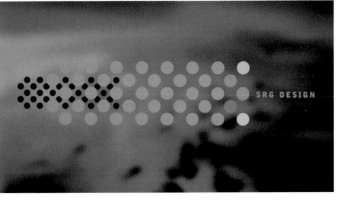

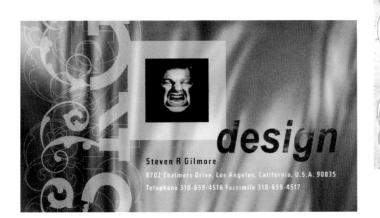

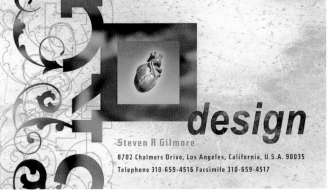

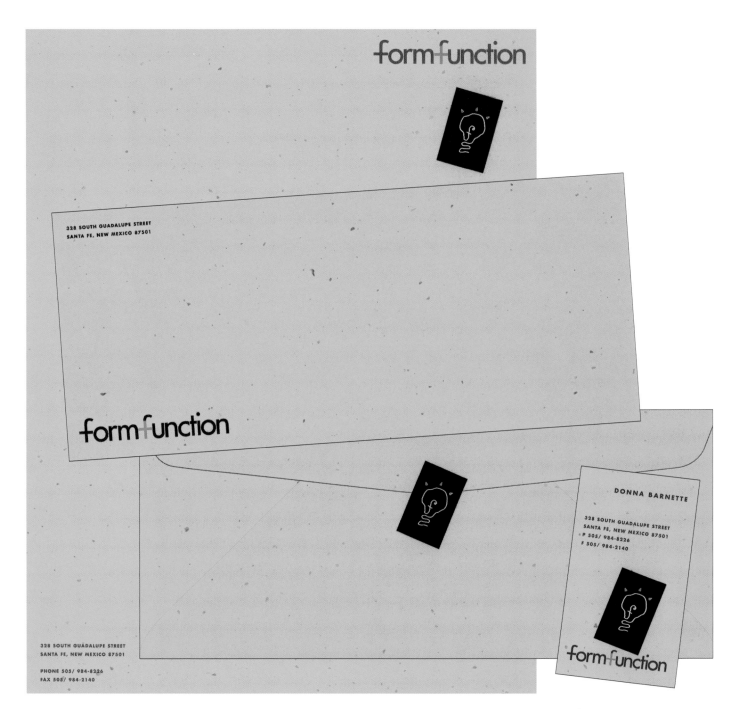

art director/studio Sandy Hill/A-Hill Design

designer/studio Sandy Hill/A-Hill Design

client/service Form + Function/lighting design

paper Fox River Confetti, Gloss Crack'N Peel

type Futura, Futura Condensed

colors Two, match (paper); five, match (labels)

printing Offset lithography

software QuarkXPress, Adobe Illustrator

concept This simple, two-color letterhead package derives much of its power from the thick, mustard-colored paper stock. For even more pizzazz at a low cost, the designer created a five-color sheet of various sized labels printed with the lightbulb illustration. Small labels are hand-applied to the stationery. Others are used for packaging and labeling.

cost $5,290

print run 5,000 (letterhead and envelopes); 3,000 (business cards); 3,400 (assorted labels)

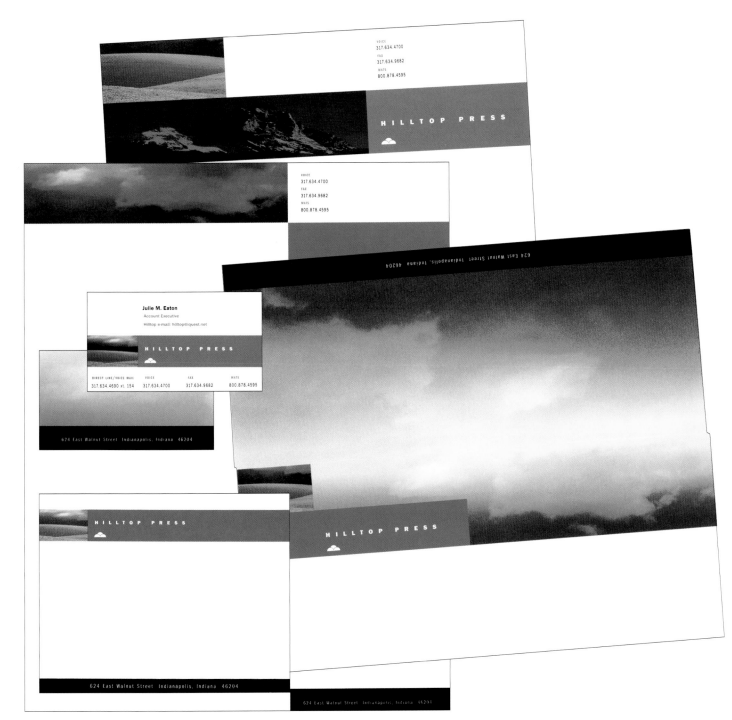

art director/studio Janet Rauscher/
Rauscher Design, Inc.
designers/studio Janet Rauscher,
Russ Jackson, Stephanie C.
Hughes/Rauscher Design, Inc.
photographer Stock
client/service Hilltop Press, Inc./
printing

paper Mohawk Options
type Franklin Gothic
colors Four, process plus one,
match
printing Offset lithography
software QuarkXPress, Adobe
Photoshop

concept Originally designed for a
new marketing program, this iden-
tity was so well-liked by the client
(and its clients) that it was adopt-
ed as the printer's official look.
The existing abstract logo (in
white beneath the company
name) represents press rollers

and a hilltop. The new look inter-
prets that image literally with a
photo of rolling hills beneath a
wide sky. On the letterhead, an
additional photo of mountain
peaks symbolizes "peak" perfor-
mance and quality.
print run 5,000

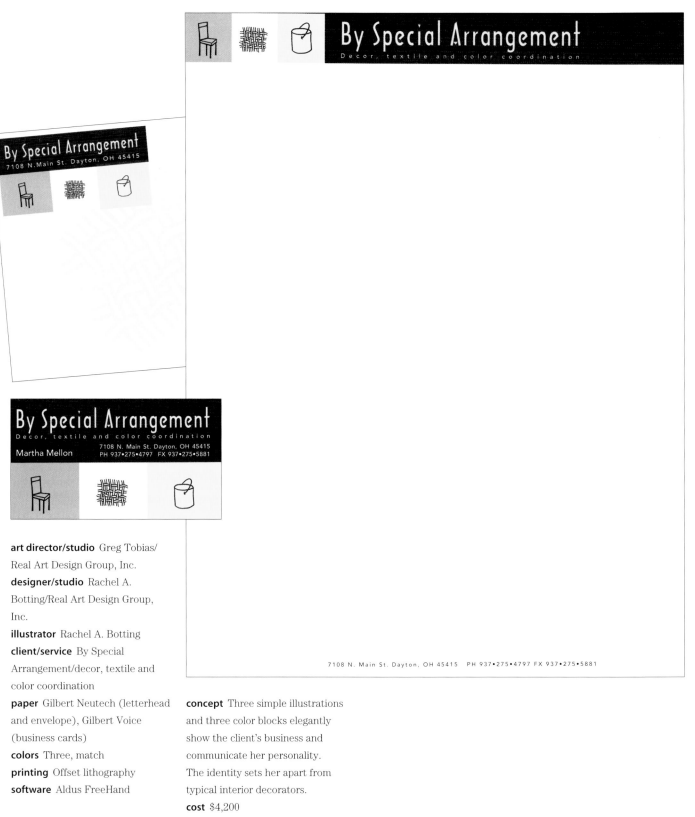

art director/studio Greg Tobias/
Real Art Design Group, Inc.
designer/studio Rachel A.
Botting/Real Art Design Group,
Inc.
illustrator Rachel A. Botting
client/service By Special
Arrangement/decor, textile and
color coordination
paper Gilbert Neutech (letterhead
and envelope), Gilbert Voice
(business cards)
colors Three, match
printing Offset lithography
software Aldus FreeHand

concept Three simple illustrations
and three color blocks elegantly
show the client's business and
communicate her personality.
The identity sets her apart from
typical interior decorators.
cost $4,200
print run 1,000

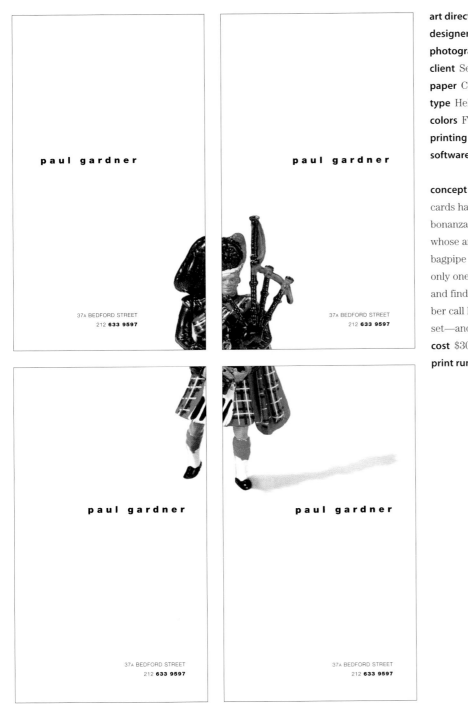

art director Paul Gardner
designer Paul Gardner
photographer Bret Wills
client Self
paper Carolina (two-sided)
type Helvetica
colors Four, process
printing Offset lithography
software QuarkXPress

concept This set of four puzzle cards have been a business bonanza for the designer, a Scot whose answering machine plays bagpipe music. Gardner gives out only one card per potential client and finds that an impressive number call him to get the complete set—and hire him as well.
cost $300
print run 2,000 (500 sheets)

type

Classic letterhead design relies on little more than type and paper for its impact. Big splashes of color and bold illustration have no place here. Elegant type on colored or textured paper can do the job for many clients.

But type can be used in other ways as well. New computer faces, or creatively used old standards, can be splashed, stretched or scrawled across a page. Letters can cover an entire surface or be squeezed into a tiny corner. Any of these innovative type treatments can make a distinct impression.

Color bars are popular design elements to combine with type. So are simple lines and patterns, or colored letters. Another ideal complement to type treatments is a patterned or solid-color second side. But even if the budget does not permit any of these additions, relying on type for a main impression is still a good bet.

art director/studio Frank Viva/
Viva Dolan Communications and
Design, Inc.
designer/studio Frank Viva/
Viva Dolan Communications and
Design, Inc.
photographer Hill Peppard
client Self
paper Conqueror High White
Wove
type Trade Gothic
colors Four, process
printing Offset
lithography
software QuarkXPress

concept This bold
package for a design firm
does much more than not
ignore the firm's initials
(VD), it makes them the
marketing focus. The
dangerous-looking logo,
showcased by the simple
black-and-white stationery
package, combines black
gothic letters and a roaring
fire. Round, kiss-cut labels
repeat the logo and various
provocative statements: "dis-
cretion guaranteed," "tell your
partners," "your reputation is
at stake."
special production technique
The envelope was printed before
conversion to ensure the bleed.
cost $3,000
print run 3,000

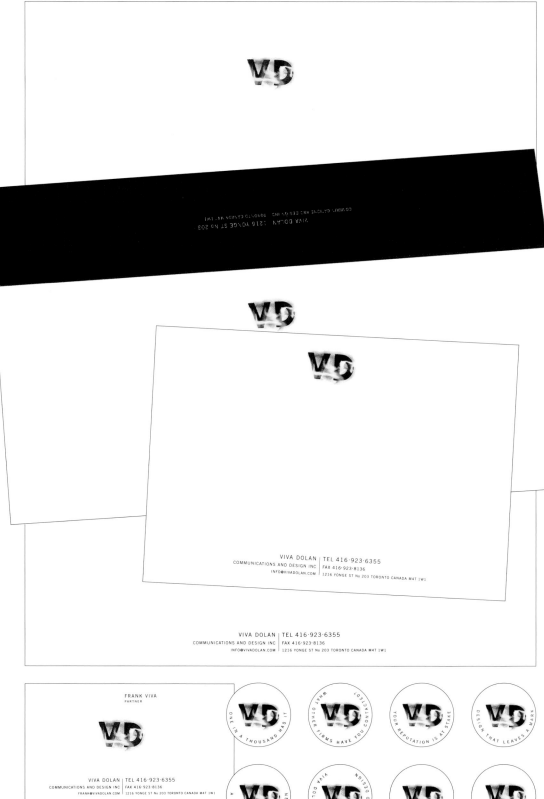

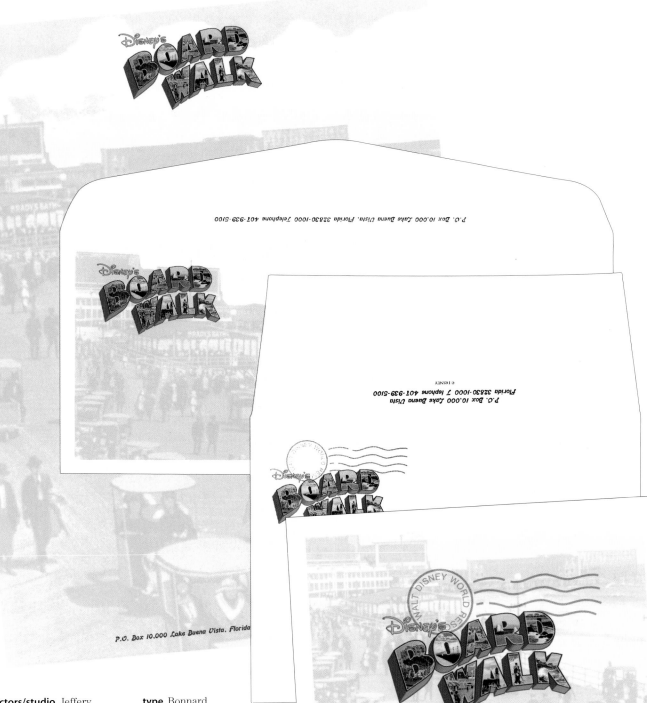

art directors/studio Jeffery
Morris, Renée Schneider, Bob
Holden/Disney Design Group
designer/studio Bob Holden/
Disney Design Group
photographer Vintage postcard
supplied by the Curt Teich
Postcard Archives
client/service Walt Disney
World®/resort
paper Mohawk Superfine
Recycled Soft White

type Bonnard
colors Four, process
printing Offset lithography
software Adobe Photoshop,
QuarkXPress

concept The nostalgic imagery
captures the feel Disney® worked
to express in the resort's architec-
ture and interiors. Classic post-
card graphics, inspired by and
taken from vintage postcards, give
the pieces a carefree and inviting
look. The Disney® logo is promi-
nent without overwhelming the
BoardWalk artwork.
cost $8,700

print run 10,000 (letterhead and
envelopes); 2,000 (note cards and
envelopes)

art directors/studio Pol Baril, Denis Dulude/K.-O. création

designers/studio Pol Baril, Denis Dulude/K.-O. création

photographer Denis Dulude

client/service Coup d'État/wine, Scotch and cigar lounge

paper Condat Supreme

type Entropy (logo) by [t-26], Courier Bold by Adobe

colors One, match

printing Offset lithography

software Adobe Photoshop, QuarkXPress

concept A shadow on cracked pavement, cast by a street lamp, announces the name of this 1990s-style lounge. Patrons are urged to come for "wine, Scotch and revolution."

budget $1,500

cost $1,250

print run 500

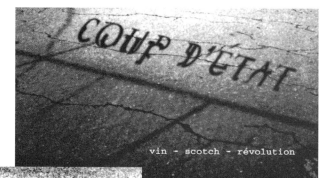

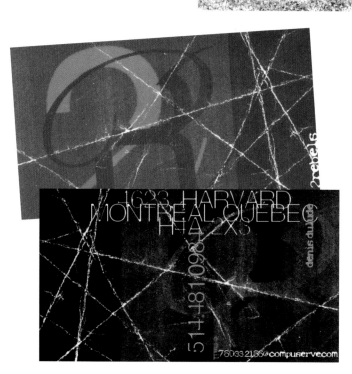

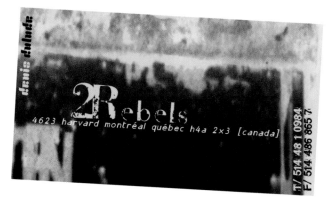

art director/studio Denis Dulude/ K.-O. création

designer/studio Denis Dulude/ K.-O. création

photographer Denis Dulude

client/service 2Rebels/type foundry

paper Condat Supreme

type Proton (name), BadDeni (2Rebels), Gonza Plus (address), Scritto (phone and facsimile); all by 2Rebels

colors Four, process

printing Offset lithography

software Adobe Photoshop, QuarkXPress

concept The paper stock has a luxuriously smooth feel that contrasts with and complements the deliberately "distressed" look of the design. Muted colors and grainy imagery characterize the style.

cost-saving technique The cards were printed with another job, so the only fees were for cutting.

cost $40

print run 1,000

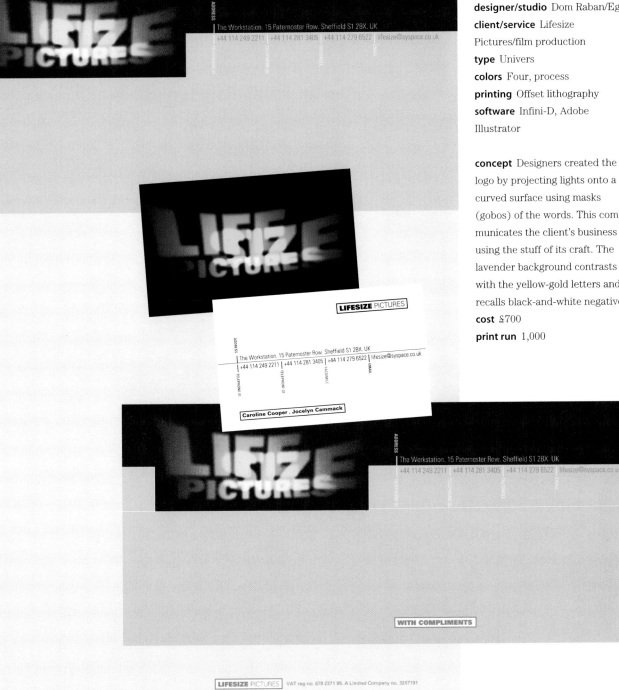

art director/studio Dom Raban/
Eg.G
designer/studio Dom Raban/Eg.G
client/service Lifesize
Pictures/film production
type Univers
colors Four, process
printing Offset lithography
software Infini-D, Adobe
Illustrator

concept Designers created the
logo by projecting lights onto a
curved surface using masks
(gobos) of the words. This com-
municates the client's business
using the stuff of its craft. The
lavender background contrasts
with the yellow-gold letters and
recalls black-and-white negatives.
cost £700
print run 1,000

design team/studio Kristin Moore, Judy Kirpich/Grafik Communications, Ltd.
portrait Cassandra Austen (collection of the National Portrait Gallery, London)
client Jane Austen Society of North America
paper Champion Mystique Laid Soft White
type Au Bauer Text Initials (address), Ignatius (logo), Colmcille (titles)
colors Two, match
printing Offset lithography
software QuarkXPress, Adobe Photoshop

concept The client wanted a classic look and design that featured Jane Austen's image. Elegant type and a dot-screen background give the piece an "old" feel. Both the envelope and letterhead feature Austen's words, one of the best-known first lines in literature: "It is a truth universally acknowledged that a single man in possession of a good fortune must be in want of a wife."

cost-saving techniques By using screens, designers gave the two-color piece the look of several colors. Design and production were donated.

special production technique The quotation on the letterhead sheet, artfully arranged for legibility, is ghosted out of the full-page screen tint.

cost $1,596 (printing)
print run 5,000

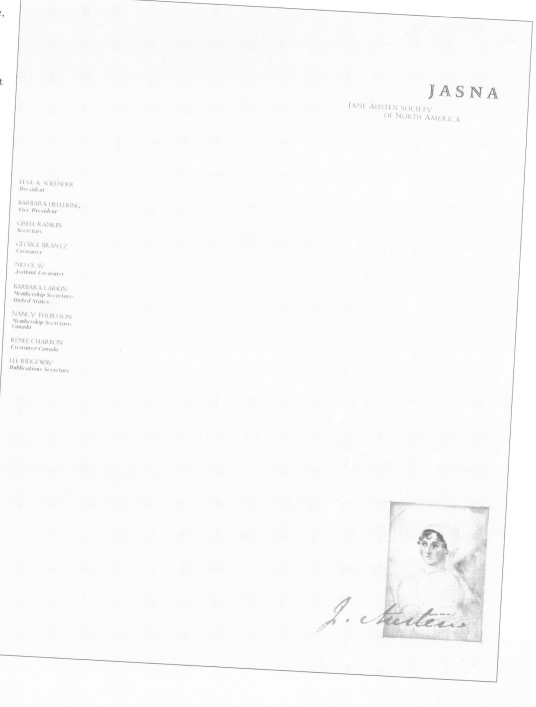

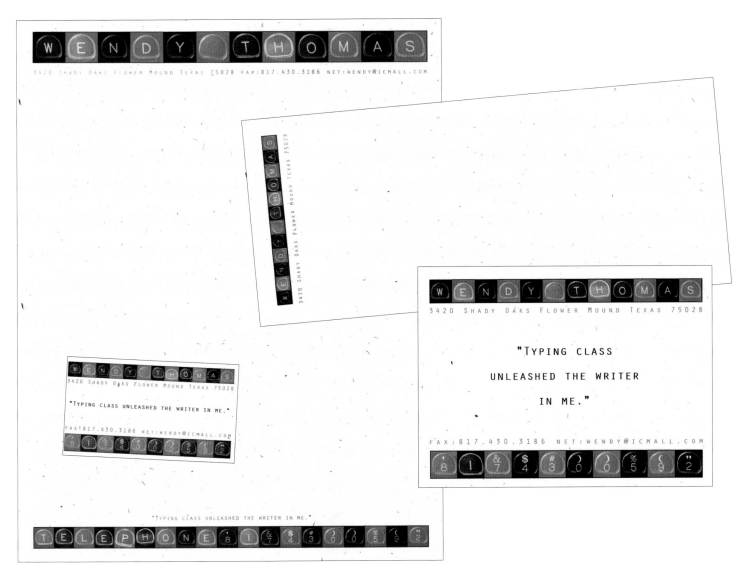

art director/studio Elena Baca/ Elena Design

designer/studio Elena Baca/ Elena Design

client/service Wendy Thomas/ copywriter

paper French Speckletone, Madero Beach White

type Oracle, Phototone Alphabets

colors One, match plus black

printing Offset lithography

software QuarkXPress, Adobe Photoshop, Adobe Illustrator

concept A comment from the client's mother ("Well, now you can use your typing skills.") inspired the typewriter imagery. Textured paper and checkered borders give this two-color piece a hefty impact, while simple type and the photographed keys keep the design centered on the client's business.

cost-saving technique The designer and client traded services.

cost $855 (printing)

print run 1,000

art director/studio Ellen Shapiro/
Shapiro Design Associates Inc.
designer/studio Ellen Shapiro/
Shapiro Design Associates Inc.
illustrator George Toomer
(cartoon character and tennis
shoes on logo)
client/service American Cancer
Society, New York City Division/
cancer research and fundraising
paper Mohawk Vellum
type Futura, Franklin Gothic,
hand-lettering, various (in logo)
colors Two, match
printing Offset lithography
software Adobe Illustrator, Adobe
Photoshop, Adobe PageMaker

concept The whimsical design
and bright colors attract interest
to the pro-
gram and give
it an upbeat,
fun feel rather
than a dour,
forbidding one.
**cost-saving
technique**
Design and pro-
duction were
done at a
reduced fee.
cost $4,000
print run 3,000
(letterhead and
press release
letterhead); 7,500 (membership
cards); 1,000 (envelopes)

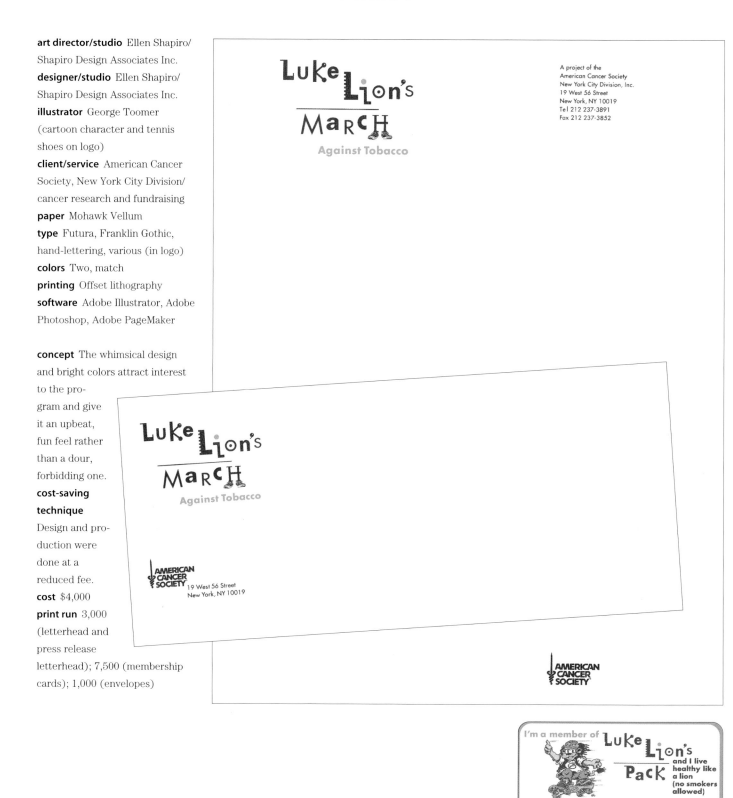

art director/studio Tim Walker/
Walker Creative, Inc.
designer/studio Tim Walker/
Walker Creative, Inc.
client/service Pinpoint Color/four-
color printer
paper Neenah Classic Crest Solar
White
type Trajan (logotype), Gill Sans
colors Four, process
printing Offset lithography
software Adobe Illustrator

concept To communicate the
client's name and show-
case its printing abilities,
the designer created a
letterhead design that
required pinpoint
precision in printing.
The perfectly aligned
color bar, repeated
twice on each piece,
displays the printer's
skill. It also communi-
cates the client's
business, four-color
printing, at a glance.
budget $3,500
cost $3,438
print run 1,000

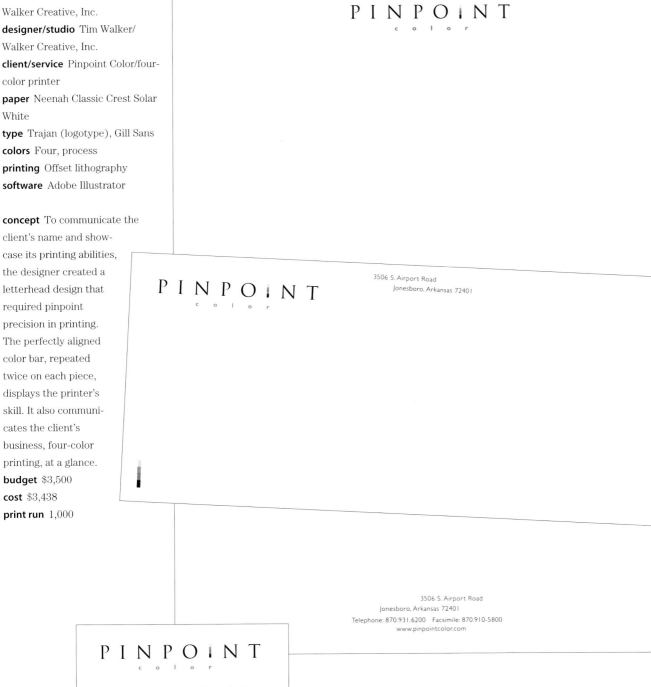

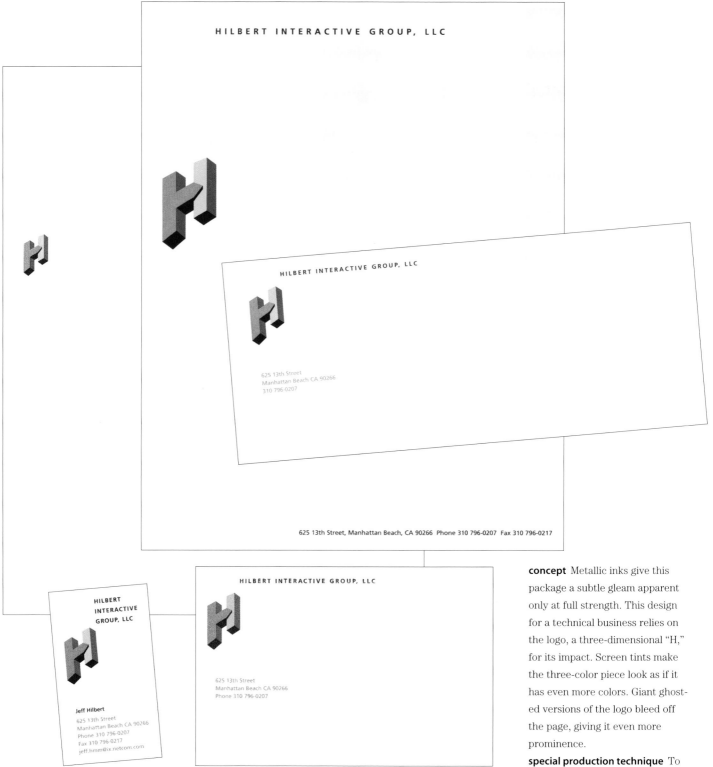

concept Metallic inks give this package a subtle gleam apparent only at full strength. This design for a technical business relies on the logo, a three-dimensional "H," for its impact. Screen tints make the three-color piece look as if it has even more colors. Giant ghosted versions of the logo bleed off the page, giving it even more prominence.

special production technique To achieve a consistent color, the backs of the business cards were double-hit with metallic green.

cost $6,568

print run 5,000 (business cards); 4,000 (letterhead and second sheets); 5,000 (labels)

art director/studio Hal Apple/ Hal Apple Design, Inc.

designer/studio Jason Hasami/ Hal Apple Design, Inc.

client/service Hilbert Interactive Group, LLC/representatives to interactive computer gaming and software developers

paper Fox River Starwhite Vicksburg (letterhead, second sheet, envelope), Fasson Crack'N Peel Plus (label)

type Frutiger

colors Three, match (one metallic)

printing Letterpress

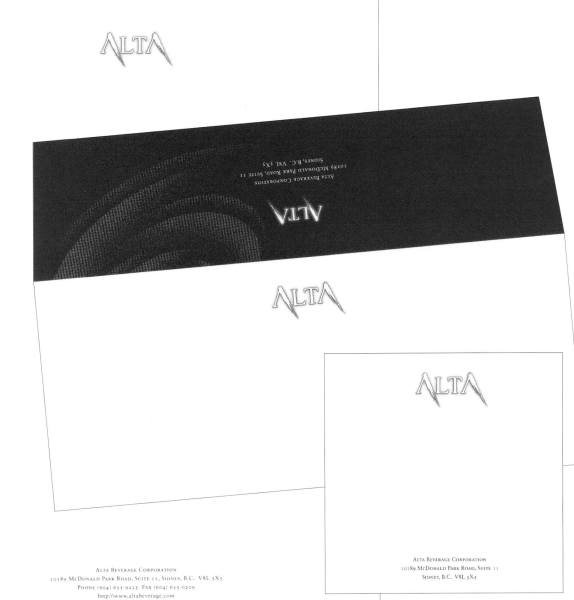

art director/studio Jack Anderson/Hornall Anderson Design Works, Inc.
designers/studio Jack Anderson, Larry Anderson, Julie Keenan/Hornall Anderson Design Works, Inc.
illustrator Dave Julian

client/service Alta Beverage Co./ bottled water distributor and bottler
paper Crane Crest
type Sabon
colors Two, match
printing Offset lithography
software Adobe Photoshop

concept The client, an Australian spring water bottler and distributor, wanted a package that would showcase its location and the pure, natural qualities of its product. The logo features customized letters made to resemble mountains and an ice-blue glow, both referring to the water's source. The glow also creates the look of embossed stationery.

special production techniques The "true-blue" color was achieved, after several tries, with a custom die blend. To keep it from smearing, pieces were printed with a nonscuffing clear coat. Envelopes were printed before conversion.

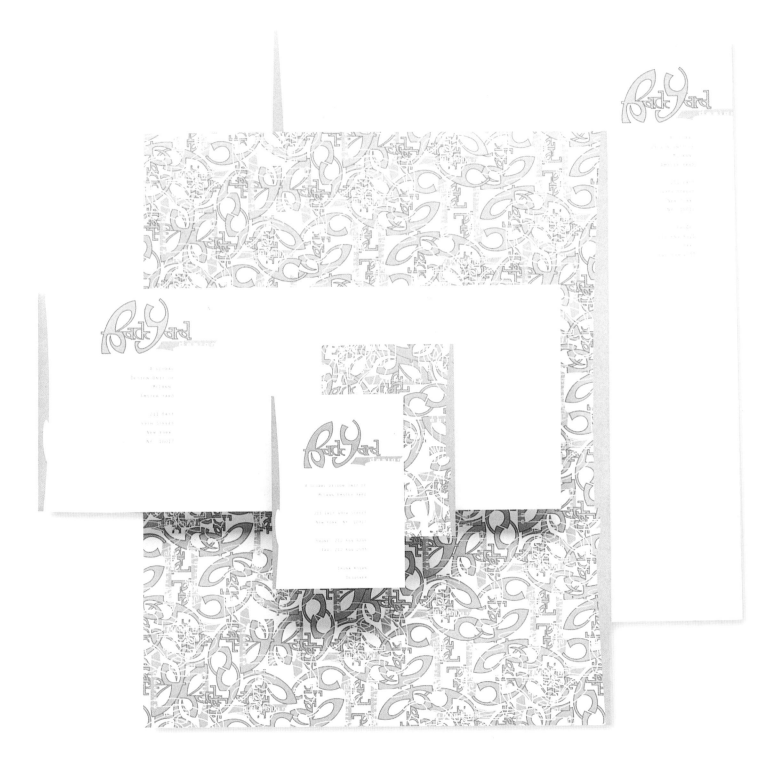

art director/studio Lorna Stovall/
Back Yard Design
designer/studio Lorna Stovall/
Back Yard Design
client Self
paper Fox River Starwhite
Vicksburg Tiara Smooth

type Hand-lettering (logo), Orator
colors Two, match metallics
printing Offset lithography
software Adobe Illustrator

concept Subtly metallic inks and
hand-lettering mark the fronts of
these pieces, which communicate
the design firm's style without
being "overdesigned." The backs

of business cards and the letter-
head first sheet, however, contain
a riotous overall pattern made up
of the logo repeated backward and
in different directions.
cost $5,000 (production and
printing)
print run 10,000

art directors/studio Pol Baril,
Denis Dulude/K.-O. création
designers/studio Pol Baril, Denis
Dulude/K.-O. création
client/service Kunst Macchina/
production company
paper French Dur-O-Tone
type Courier (logo and E-mail
address), Pure (address and
phone number); both by Garage
Fonts
colors One, match
printing Offset lithography
software Adobe Photoshop,
QuarkXPress

concept The client uses names
of mental diseases for the software
it designs for stage lighting. The
letterhead look matches that
sensibility—a little "messed up."
budget $2,500
cost $2,500
print run 1,000

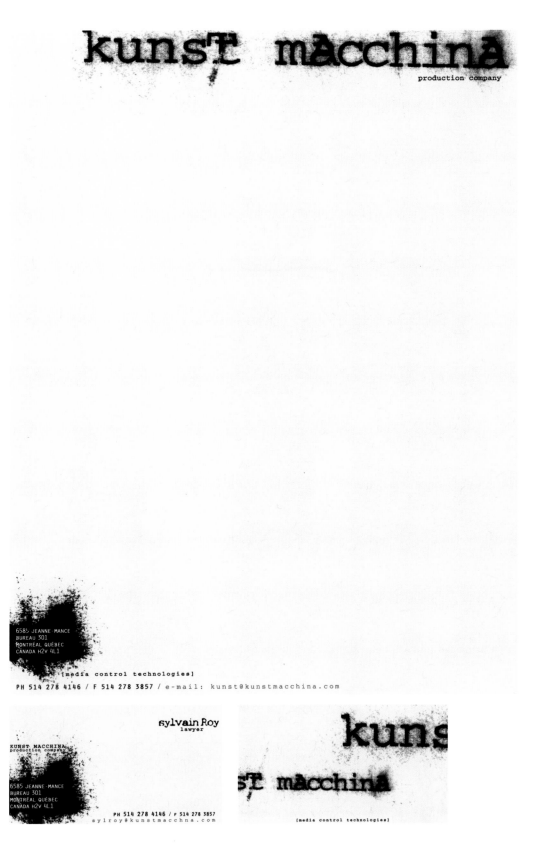

art director/studio Gary Baker/
Baker Design Associates
designer/studio Tom Devine/
Baker Design Associates
illustrator Peter Boerboom
client Self
paper Fox River 100% Cotton
Select
type Meta, Bodoni
colors Two, match
printing Offset lithography,
engraving
software Adobe Illustrator,
QuarkXPress, Adobe Photoshop

concept On the surface, these
stationery pieces are simple and
classic: engraved in pleasant
match blue and green. The reverse
sides of the letterhead and busi-
ness cards (envelopes are simply
white), however, reveal a complex
diamond pattern. As classic as the
engraving, the pattern adds a
dynamic and surprising twist to
the all-type covers.
special production technique To
achieve the numerous blue and
green shades, the sheets were
overprinted in several tint combi-
nations.

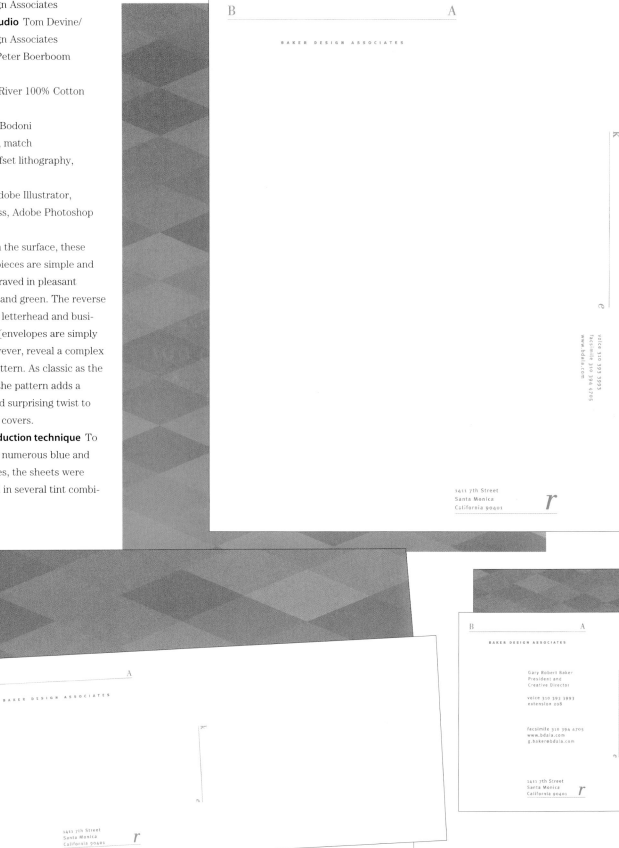

art director/studio John Reger/
Design Center
designer/studio Todd Spichke/
Design Center
client/service Wall Street
Advisors/financial advisors
paper Strathmore Writing
type Palatino
colors Four, match
printing Offset lithography
software QuarkXPress

concept The client wanted a
look that would set it apart from
competitors. This package uses
classic engraved money designs
to instantly communicate its
business. Instead of being placed
together, the firm's initials (WSA)
are placed in a loose frame around
the pieces. This adds a dynamic
feeling, and also recalls the
familiar design of U.S. bills.
cost-saving techniques Each
piece uses only two colors. On
business cards, the "S" is larger
than the other initial letters but is
ghosted for the look of a third
color.
cost $6,400
print run 2,000

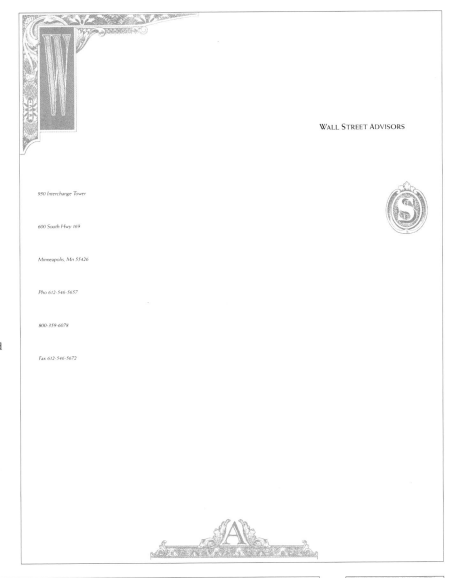

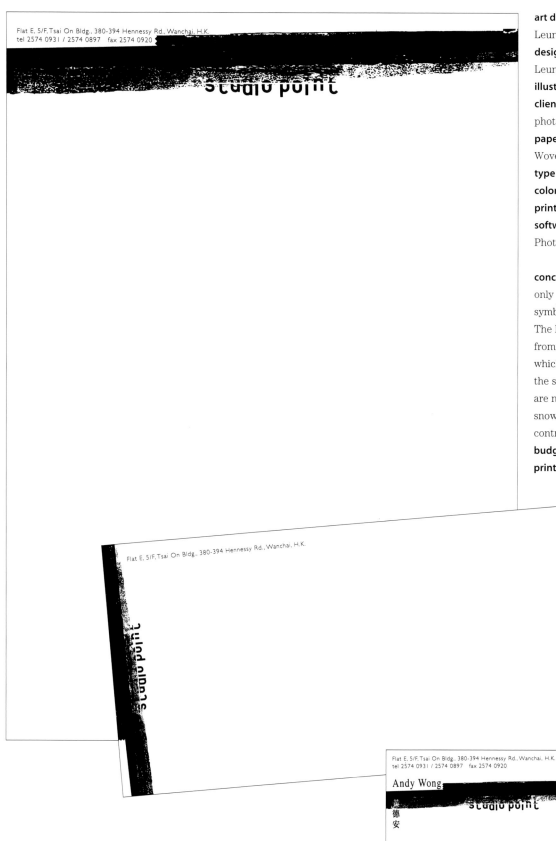

Flat E, 5/F, Tsai On Bldg., 380-394 Hennessy Rd., Wanchai, H.K.
tel 2574 0931 / 2574 0897 fax 2574 0920

studio point

art director/studio James Wai Mo
Leung/Genesis Advertising Co.
designer/studio James Wai Mo
Leung/Genesis Advertising Co.
illustrator James Wai Mo Leung
client/service Studio Point/
photography studio
paper Conqueror Diamond White
Wove
type Frutiger, Times
colors Black
printing Offset lithography
software Adobe Illustrator, Adobe
Photoshop

concept Black ink was chosen not
only to meet the budget, but to
symbolize the client's business.
The logo resembles the marks
from photographic developing,
which reflects the uniqueness of
the studio's work since the marks
are never the same. Black on the
snowlike paper creates a sharp
contrast and strong impression.
budget $4,500
print run 2,000

Flat E, 5/F, Tsai On Bldg., 380-394 Hennessy Rd., Wanchai, H.K.

studio point

Flat E, 5/F, Tsai On Bldg., 380-394 Hennessy Rd., Wanchai, H.K.
tel 2574 0931 / 2574 0897 fax 2574 0920

Andy Wong

莫
德
安

studio point

art directors/studio Pol Baril,
Denis Dulude/K.-O. création
designers/studio Pol Baril, Denis
Dulude/K.-O. création
photographer Serge Barbeau
client Self
paper Condat Supreme (business
card), French Dur-O-Tone
Butcher Off White (letterhead and
envelope), printer's stock, Avery
label paper
type GonzaPlus and Scritto
Politto (most pieces), Tex (busi-
ness card), BadDeni (business
card), Perceval (postcard)—all by
2Rebels; Tetsuo Organic (name on
business card) by [t-26]; Franklin
Gothic and Snell Roundhand
(labels) by Adobe; hand-lettering
colors Four, process (business
cards); various match colors
printing Offset lithography
software Adobe Photoshop,
QuarkXPress

concept Although few of these
pieces match each other, all share
the firm's design sensibility. Few
lines are parallel, the colors are
muddy and even the typefaces
rarely have consistent stroke
widths. In their ordered disorder,
the many parts of this stationery
package show a mastery of a dis-
tinctive 1990s look.
special production technique For
the weathered look on the mailing
and computer disk labels, design-
ers "roughed up" the type with
sandpaper.
cost $40
print run 1,000

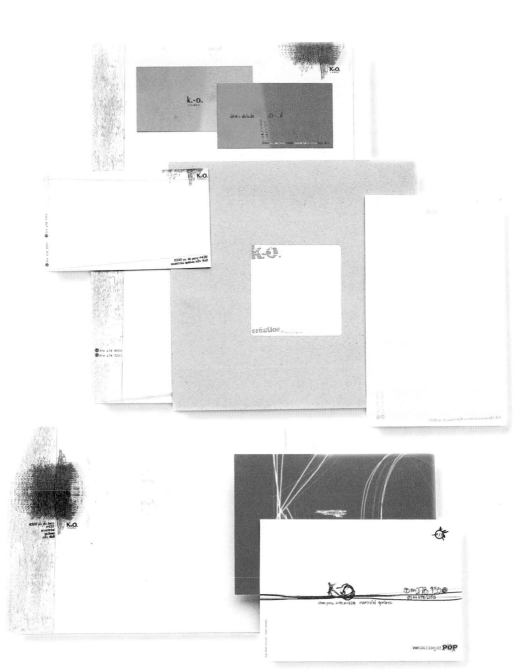

repertoire 114 boylston street boston massachusetts 02116

repertoire 114 boylston street boston massachusetts 02116

repertoire

repertoire 114 boylston street boston massachusetts 02116
617 426 3865 fax 617 426 1879 info@repertoire.com

design director/studio Anita
Meyer/plus design inc.
designer/studio Anita Meyer/plus
design inc.
client art directors Celeste
Cooper, Richard Garofalo
client/service Repertoire Inc./
furniture and accessories store,
interior design
paper Strathmore Elements White
Text (letterhead), Champion
Kromekote C1S (business card
and envelope), Fasson Crack'N
Peel Plus C1S (label)

type Didot (symbol), Letter
Gothic (address)
colors Three, match
printing Offset lithography
software QuarkXPress

concept This clean and ultramod-
ern design treatment expresses
the client's personality and the
kind of products available in the
store. The soft brown-gray that
dominates the set is distinctive
but cool, restrained rather than
emotional. The client's name, its

elegant typography
spilling off the page,
communicates an
upscale and contemporary
style.
print run 1,000–5,000

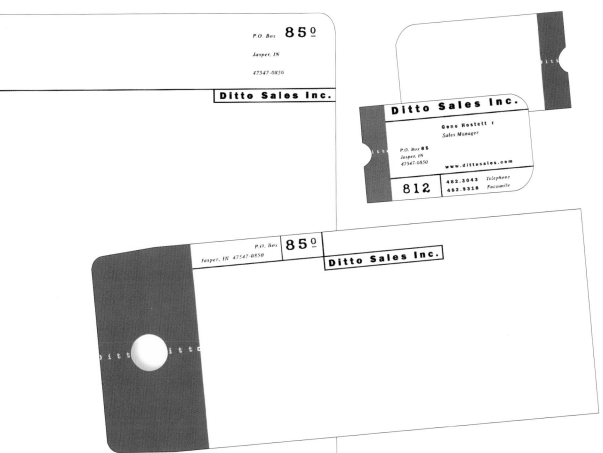

art director/studio Janet Rauscher/Rauscher Design, Inc.
designer/studio Susan D. Morganti/Rauscher Design, Inc.
client/service Ditto Sales, Inc./manufacturer's representative for furniture hardware, furnishing supplies, woodworking machinery and custom fabricated metal furniture parts
paper French Frostone Flurry
type American Typewriter, Franklin Gothic, Times
colors Two, match
printing Offset lithography
software Aldus FreeHand

concept Warm colors, clear type and printed graph (on notepaper) give this piece an industrial look suited to the client's business, but give it enough distinction to communicate its established, respected presence. Each piece includes a "distressed" number, actually part of the address or telephone number, imitating a numbered form.

special production technique The die-cut "D" on all pieces reinforces the client's name and makes the letterhead distinctive.

print run 2,000

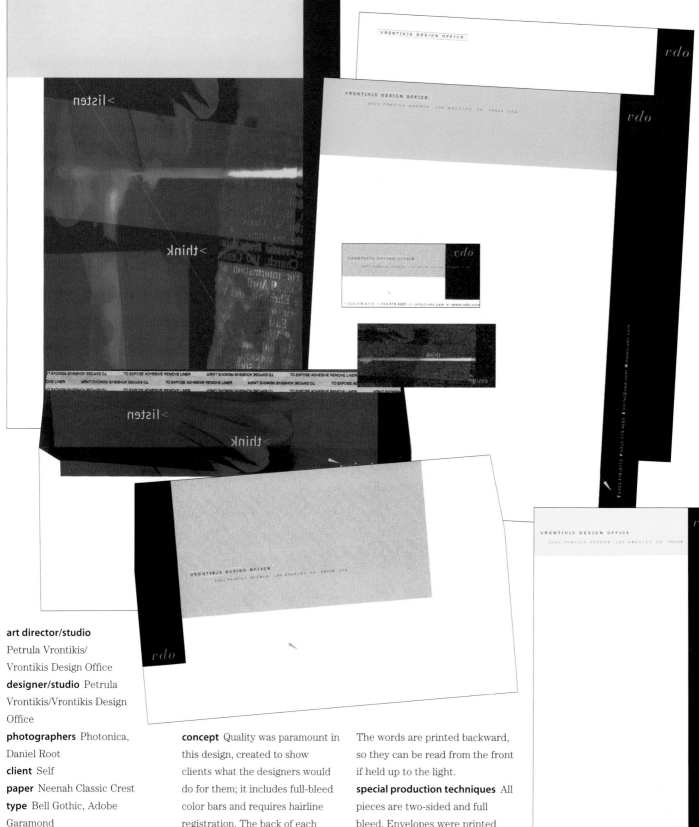

art director/studio
Petrula Vrontikis/
Vrontikis Design Office
designer/studio Petrula
Vrontikis/Vrontikis Design
Office
photographers Photonica,
Daniel Root
client Self
paper Neenah Classic Crest
type Bell Gothic, Adobe
Garamond
colors Four, process
printing Offset lithography
software QuarkXPress

concept Quality was paramount in this design, created to show clients what the designers would do for them; it includes full-bleed color bars and requires hairline registration. The back of each piece and the inside of the envelope are printed with the firm's pledge to "listen, think, design."

The words are printed backward, so they can be read from the front if held up to the light.

special production techniques All pieces are two-sided and full bleed. Envelopes were printed before conversion.

cost $15,000 (including design)

print run 2,500

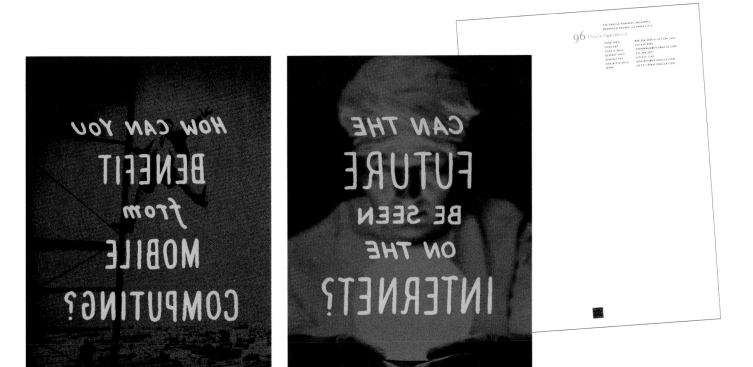

art director/studio Bill Cahan/
Cahan & Associates
designer/studio Bob Dinetz/
Cahan & Associates
photographer Stock
client/service Oracle Corporation/
computer technology
paper Hammermill Smooth
type Caslon, Futura
colors Two over six, match
software QuarkXPress

concept This package, used for a
direct-mail campaign to advertise
a conference, combines a clean
technological look with a human
touch. Each page has a simple
white front. The backs, however,
are printed with fanciful photos
and hand-lettered messages.
Both are printed backward in
order to be visible from the front.
The messages ask questions ("Is
your data safe?" "Can the future
be seen on the Internet?") and
imply that all questions will be
answered at the conference.

cost-saving techniques All photos
are stock.
special production techniques All
messages were hand lettered.

art director/studio Lori B. Wilson/
David Carter Design Associates
designer/studio Sharon LeJeune/
David Carter Design Associates
illustrator Tracy Huck
client/service Dani-Kent
Rathbun/food and catering
services
paper Fox River Starwhite
Vicksburg
type Futura
colors Two, match
printing Offset lithography
software QuarkXPress, Adobe
Illustrator

concept This simple package
emphasizes the colorful logo.
Simple type, bright white papers
and colored bars contrast with the
logo, which is made up of letters
in four styles and four colors.
special production technique
Die cuts on all pieces, including
the converted envelope flap and
foldover business cards, give the
piece further distinction.

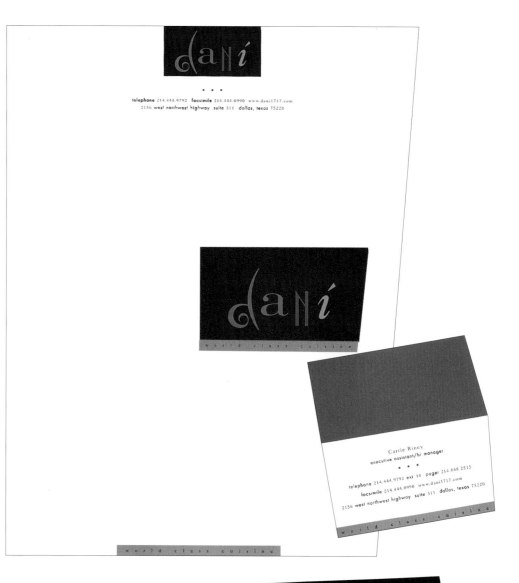

art directors/studio Steve Carsella, Chris Jones, Scott Sugiuchi/Backbone Design
designers/studio Steve Carsella, Chris Jones, Scott Sugiuchi/Backbone Design
logo design Mark Frankel/Disney® Design Group
photographer Michael Lowry
client Walt Disney World® Food and Beverage/Disney's® Culinary Academy
paper Strathmore Elements Zigzag Text
type Democratica
colors Three, match over four, process (letterhead); four, process (envelope)
printing Offset lithography
software Adobe Illustrator, Adobe Photoshop

concept To attract a young target audience to the culinary academy, the stationery package has an intriguing, contemporary look. Patterned paper gives an overall texture, while a photo of type projected on a chef's hat emphasizes feelings about food. Used at two sizes, the photograph creates an aura of mystery that makes the recipient want to investigate further.
special production techniques The photograph was achieved by typesetting slides and projecting them onto a chef's hat. Envelopes were printed before conversion.
print run 5,000

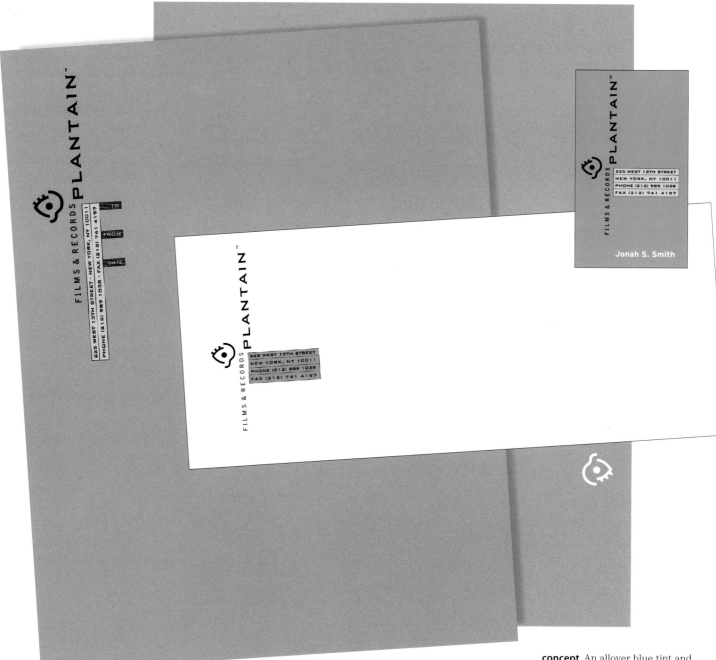

art director/studio Leslie Smolan/Carbone Smolan Associates
designer/studio Daryl Roske/ Carbone Smolan Associates
illustrator Daryl Roske
client/service Plantain Film & Records/film and record company

paper Fox River Starwhite Vicksburg
type Bank Gothic, Bell Gothic
colors Two, match
printing Offset lithography, engraving
software Adobe Illustrator

concept An allover blue tint and two dot screens give this two-color package the look of four colors. Blue in front and white on the back, the letterhead and business card have a more distinctive look than they would if simply printed on blue paper. Engraving gives the type and clever logo (an eye and ear, symbolizing the company's two products) extra crispness and texture.
cost $8,800
print run 1,000

art director/studio Jack Anderson/
Hornall Anderson Design Works,
Inc.
designers/studio Jack Anderson,
Debra McCloskey, Lisa Cerveny,
David Bates/Hornall Anderson
Design Works, Inc.
illustrator John Fretz
client/service Stewart Capital
Management/capital investments
paper Strathmore Elements
colors Three over two, match
printing Offset lithography,
engraving, embossing
software Aldus Freehand,
QuarkXPress

concept The lined paper
reinforces the logo—a column
made of the firm's initials that is
meant to convey the impression of
a strong investment foundation
and potential for growth. Dark
green ink with a bright green glow
recalls the feel of money and stock
certificates. Engraving and
embossing add to that impression.
special production techniques
The name and logo are engraved
for an extra-rich look. All pieces,
including the converted
envelopes, are printed
on the second side with
a decorative design
reminiscent of the
old-fashioned engraved
designs on money and
stock certificates.

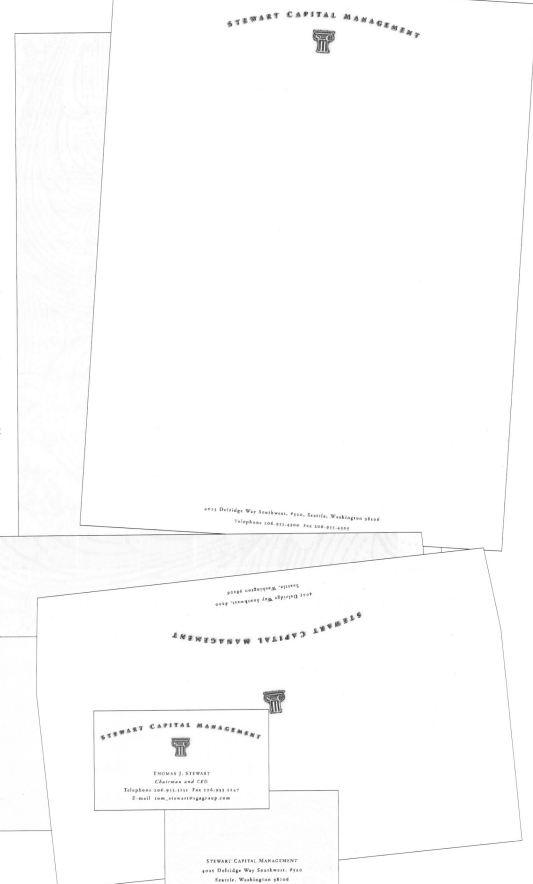

low-budget projects

The low-budget project can be the bane of a designer's existence, or it can be an exciting challenge. With a low-budget project, the client usually has everything to lose. This letterhead project is all he or she can afford, perhaps for months or even years. It has to do the job right—unless it does, there may never be a second chance.

In this chapter, you'll find projects that do a lot with a little. Some make a low budget into an asset, producing a package that's stylishly down-at-the-heels. Others spend the bulk of the client's money on one expensive but attention-getting element: a heavy paper, a die cut, engraving or embossing. And still others simply rely on a strong design in one or two colors, with ordinary offset printing on common paper stocks.

All present the client in an innovative way that suits his, her or their profession. Whether whimsical or sober, these pieces make the right impression without spending one extra cent.

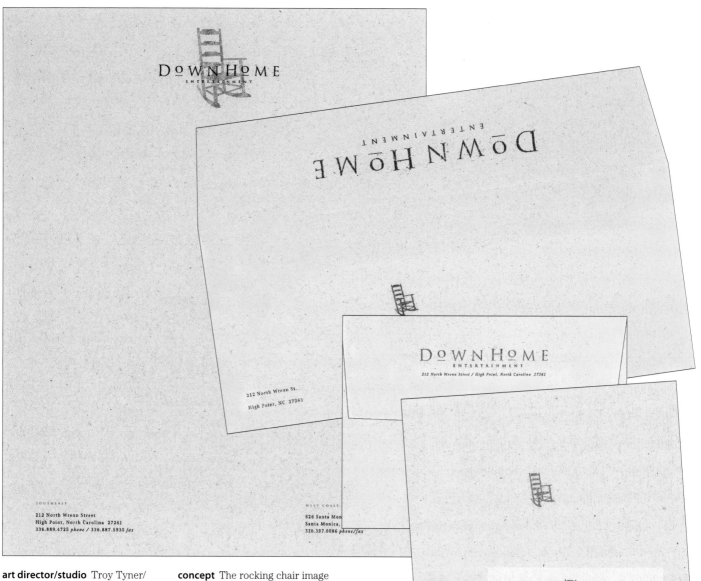

art director/studio Troy Tyner/
Henderson Tyner Art Co.
designer/studio Troy Tyner/
Henderson Tyner Art Co.
illustrator Will Hackley
client/service DownHome
Entertainment/film production
paper Neenah Classic Laid
type Trajan
colors Two, match
printing Offset lithography
software Aldus FreeHand

concept The rocking chair image
symbolizes the client's focus on
Southern writers and filmmakers,
and recalls telling tales on the
veranda. Textured papers add to
the simple illustration and typog-
raphy without being distracting.

simply music
INTERNATIONAL

1009 22nd street. sacramento california 95816. telephone 916 554 7654. facsimile 916 554 7656. email simplymusic@rcip.com. internet www.simply-music.com

art director/studio Jane Jeffrey/ Smart Works Pty. Ltd.
designer/studio Paul Smith/Smart Works Pty. Ltd.
illustrator Paul Smith
client/service Simply Music International/a new method of teaching music
paper Mohawk Superfine White Eggshell
type Avenir
colors Two, match
printing Offset lithography
software Adobe Illustrator, QuarkXPress

concept The design for this package is meant to appeal to people of all ages and backgrounds, and from all walks of life. The playful logo, a smiling face made of musical notes, and the horizontal bars symbolizing musical tones both represent music as simple and natural.
budget $3,000 (design)

art directors/studio Virna
Gonzalez, Stuart Lowitt/Spring.
Design Group, Inc.
designers/studio Virna Gonzalez,
Stuart Lowitt/Spring. Design
Group, Inc.
illustrator Virna Gonzalez
photographer George Kerrigan
client Self
paper Mohawk Superfine Text
(letterhead and envelope), Cover
(card)
type Hand-lettering, Blur, Joanna
colors Two, match
printing Offset lithography
software Adobe Photoshop,
QuarkXPress

concept Curling, handwritten
letters, soft colors and a photo-
graph of an egg subtly refer to the
season that shares this firm's
name. Other meanings for the
word, having to do with balance
and timing, are ghosted onto both
sides of the business cards and the
back of the stationery. The simple
design nevertheless reveals the
firm's sense of humor, titling the
principals "head muckety-muck"
and "head honcho."
special production technique
The backs of the letterhead are
printed in light yellow with ghost-
ed words and images resembling
watermarks.
cost $1,400
print run 500

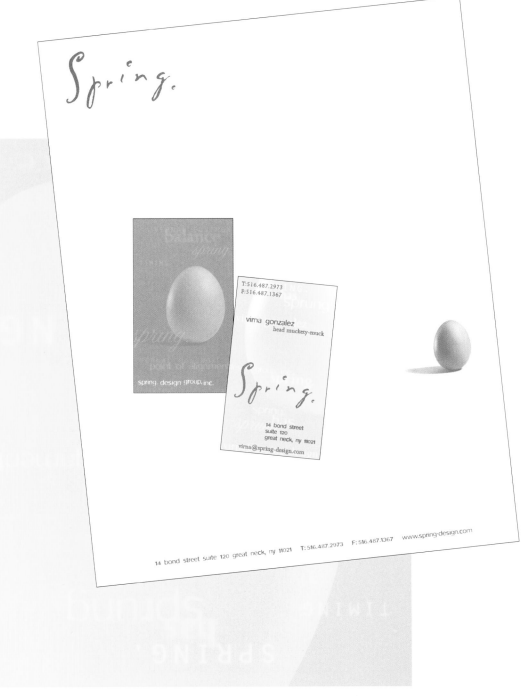

119 COULTER AVENUE, ARDMORE, PA 19003

TELEPHONE (610) 896-0800

NEDRA FETTERMAN PhD
The Relationship Center

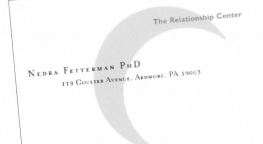

The Relationship Center

NEDRA FETTERMAN PhD
119 COULTER AVENUE, ARDMORE, PA 19003

IMAGO WORKSHOPS

Professional Training

Clinical Supervision

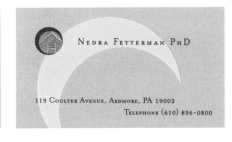

art director/studio Marylou F. Hecht/Dyad Communications
designer/studio Marylou F. Hecht/Dyad Communications
photographer Stock
client/service Nedra Fetterman, The Relationship Center/ psychotherapy
paper Strathmore Writing Soft White
type Mrs. Eaves, Gill Sans
colors Two, match
printing Offset lithography
software QuarkXPress

concept This simple but striking package uses dot screens of two match colors to create the appearance of four colors. Off-white paper increases the sense of color. Celestial symbols and images of the home are important symbols in the client's form of psychotherapy.
cost $2,500
print run 1,000

art director/studio Claudia Gamboa/Dupla Design

designer/studio Ney Valle/Dupla Design

illustrator Claudia Gamboa

client/service Duerê Rio Produções/cultural productions

paper Offset (letterhead), Opaline (card)

colors Two, match

printing Offset lithography

software Adobe Illustrator

concept A simple but effective image—a "talk balloon" filled with music notation—is carried throughout this multiple-piece letterhead package for an organization that plans cultural events. The bright match yellow draws attention to itself and requires no more than a sparing use.

special production technique Envelopes were printed before conversion.

cost $7,500

print run 3,000

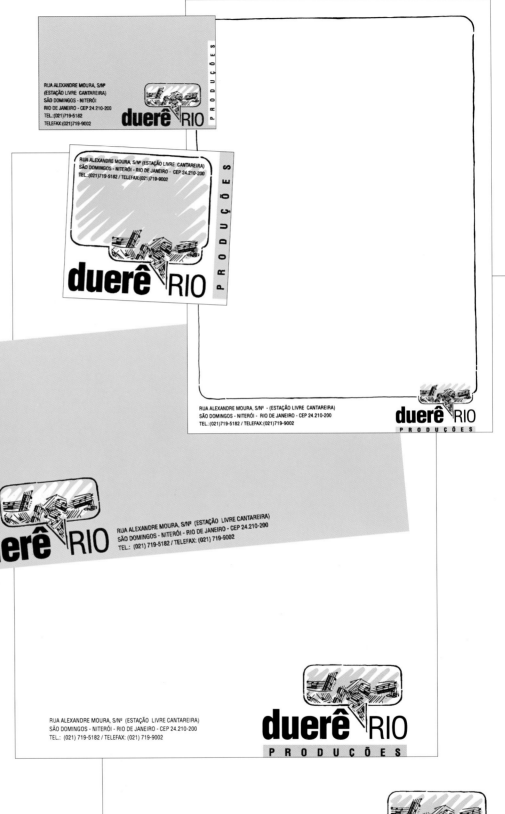

art director/studio Matt Graif/
Graif Design
designer/studio Matt Rose/
Graif Design
client Self
paper Mohawk Superfine
type Helvetica Rounded
colors Four, match
printing Offset lithography
software Adobe Illustrator

concept The designers punched up their existing identity with vivid colors and improved on previous packages by using a bolder design. They report that the resulting package has received more positive comments and brought them more work.
special production techniques Instead of printing the plain envelopes, designers created a wraparound, two-color label that sealed the letters and provided return address information. The labels could also be used at full length. Die-cut corners added further distinction.
budget $1,500
cost $1,500
print run 1,000

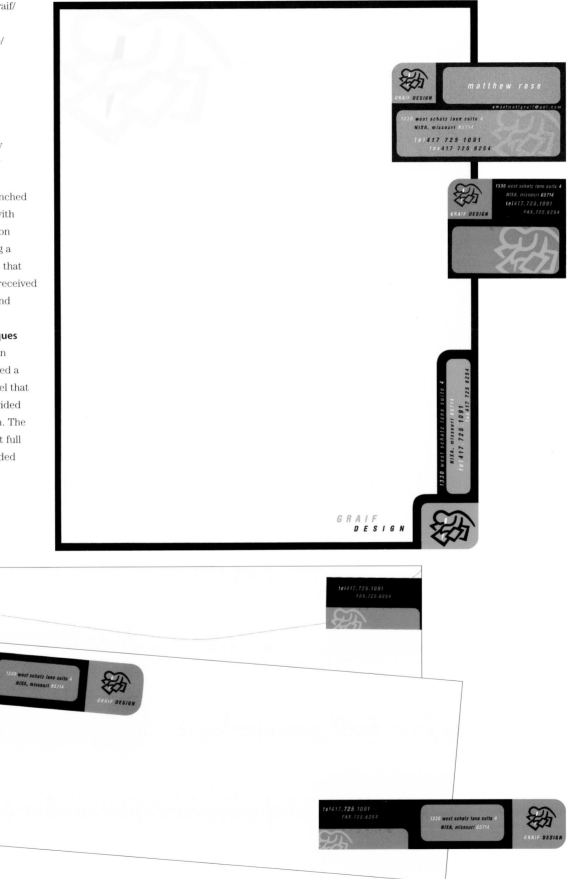

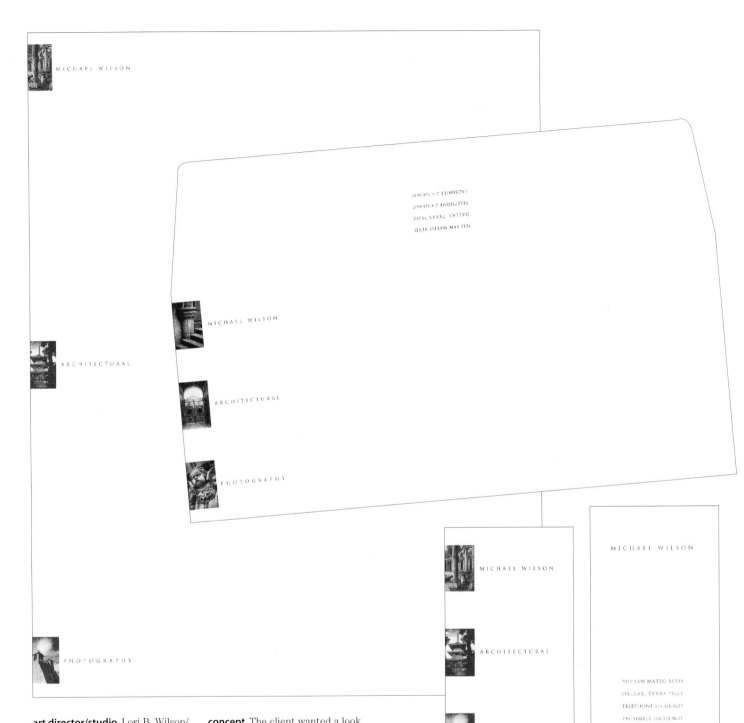

art director/studio Lori B. Wilson/
David Carter Design Associates
designer/studio Randal Hill/David
Carter Design Associates
photographer Michael Wilson
client/service Michael Wilson/
architectural photography
paper Fox River Starwhite
Vicksburg
colors Four, match
printing Offset lithography
software QuarkXPress

concept The client wanted a look
that was both fun and profession-
al. Tiny photographs of sites
around the world, beautifully
printed, pique the recipient's
interest, while the elegant type
gives the package an air of sub-
stance and professionalism.
special production technique
Envelope flaps have a special die-
cut edge.

art director/studio
Juli Shore/Jart Design and
Illustration

designer/studio
Juli Shore/Jart Design and
Illustration

illustrator
Joanne Holmgren

client/service
Kick/specialty boutique

paper Lexanne Velvet Finish
(business card), Loose
Ends/Dixon Paper Silver Wash
(letterhead and envelopes)

type Helvetica

colors One, match

printing Screenprinting (business
card), laser printing (letterhead
and envelope)

software Aldus FreeHand

concept To give this package for a
specialty clothing shop a unique
character that matched its one-of-
a-kind merchandise, the designer
specified plastic-shaped business
cards and silver-washed Kraft
paper. The shop's logo, designed
by its owner, is the only artwork.
The type treatment is deliberately
simple. For further versatility, the
designer printed half the letter-
head sheets on the paper's silver
side and half on its Kraft side.

cost-saving technique
The letterhead and envelopes
were printed in-house, because of
the small quantities needed.

special production technique
The plastic business cards were
screenprinted at a sign shop.

budget $1,200

cost $1,194 plus trade in mer-
chandise

print run 500 (business cards);
250 (letterhead and envelopes)

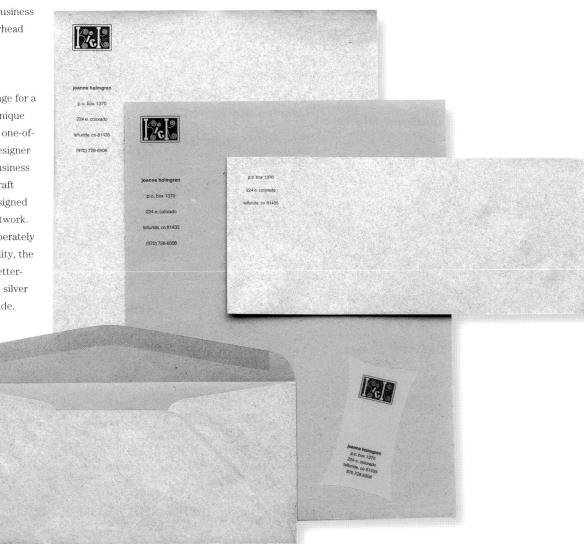

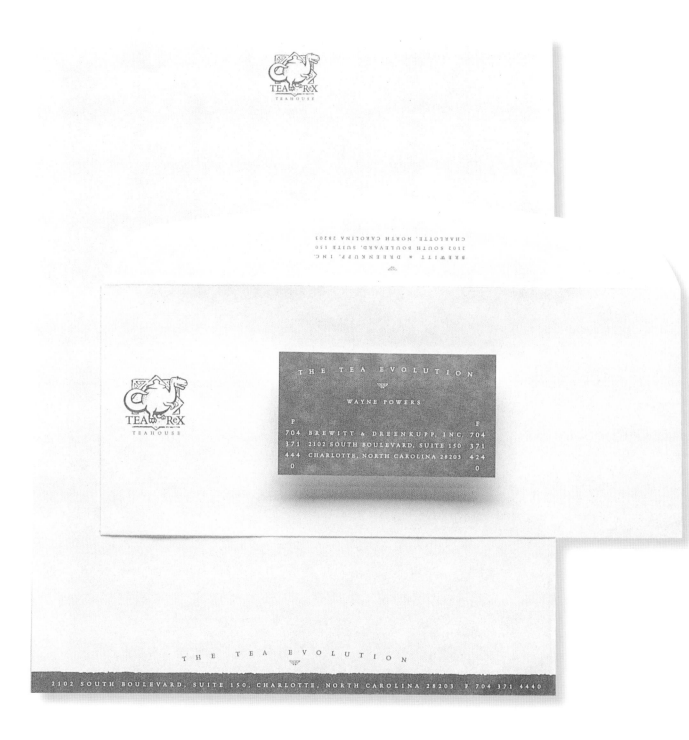

art director/studio Patrick Short/
BlackBird Creative
designer/studio Brandon Scharr/
BlackBird Creative
illustrator Brandon Scharr
production Pam Allen
client/service Tea Rex
Teahouse/serving tea products
from around the world

paper Georgia-Pacific Skytone
White
type Celestia Antiqua
colors One, match metallic
printing Offset lithography
software Adobe Illustrator

concept Sophisticated type,
parchment paper and metallic
ink suggest a sophisticated atmos-
phere and a touch of whimsy.
The vertical arrangement of phone
and fax numbers on the two-sided
business card does the same.
budget $5,200
cost $4,926
print run 1,000

art director/studio Mary F. Pisarkiewicz/Pisarkiewicz Mazur & Co., Inc.

designers/studio Kerstin Betzemeier, Minah Kim, Jen Harenberg, Nat Estes/Pisarkiewicz Mazur & Co., Inc.

client Self

paper Strathmore Writing

type Base Nine Small Caps

colors Two, match

printing Offset lithography

software Adobe Photoshop, QuarkXPress

concept This two-color package uses computer retouching to achieve its "eclipse" and shadow effects. The four eclipse stages symbolize the multidiscipline design firm's style of work and its commitment to "solid design for strategic problem solving."

budget $5,000

cost $5,042

print run 1,500 (envelopes); 2,500 (letterhead); 1,000 (label sheets)

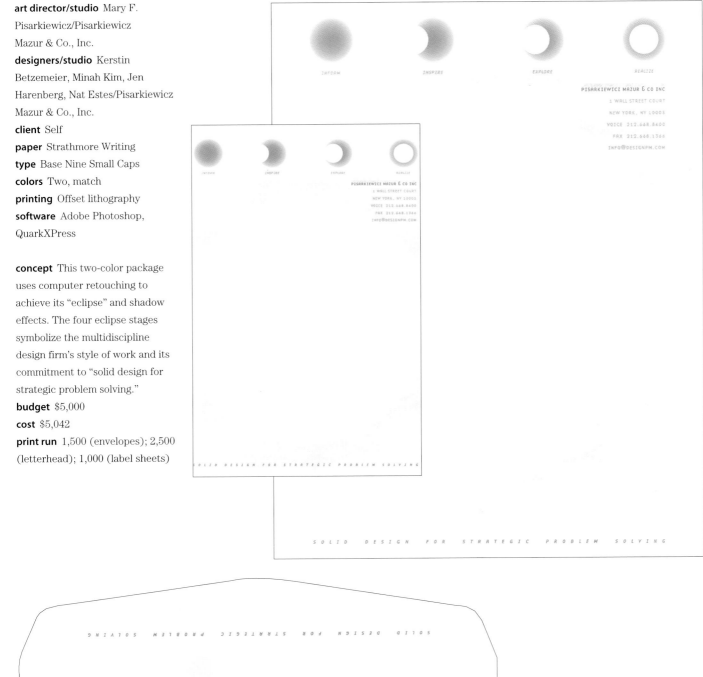

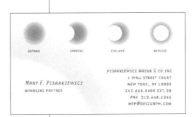

designer/studio Rick Tharp/
Tharp & Drummond Did It
illustrator Nicole Coleman
client/service The Dashboard
Company/scooter (pedalless
bicycle) manufacturer
paper Fox River Starwhite
Vicksburg
colors Two, match
printing Offset lithography

concept This simple package
relies on the logo to communicate
its client's unusual business. The
illustration and vintage look are
intended to show scooters as fun,
"retro" products that have been
undeservedly overlooked.

THE DASHBOARD CO. 540 SANTA CRUZ AVE. MENLO PARK, CALIFORNIA 94025 USA

FAX: 415.329.8033 PHONE: 415.327.6577

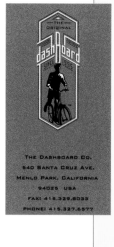

The Original American Scooter Company

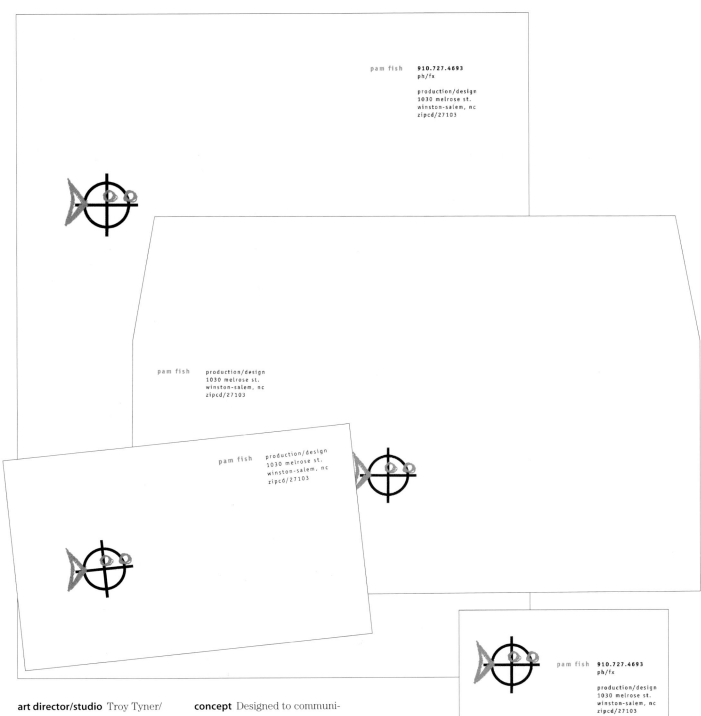

pam fish **910.727.4693**
ph/fx

production/design
1030 melrose st.
winston-salem, nc
zipcd/27103

pam fish production/design
1030 melrose st.
winston-salem, nc
zipcd/27103

pam fish production/design
1030 melrose st.
winston-salem, nc
zipcd/27103

pam fish **910.727.4693**
ph/fx

production/design
1030 melrose st.
winston-salem, nc
zipcd/27103

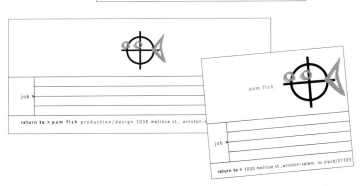

job >

return to > **pam fish** production/design 1030 melrose st., winston-s

pam fish

job >

return to > 1030 melrose st.,winston-salem, nc zipcd/27103

art director/studio Troy Tyner/
Henderson Tyner Art Co.
designer/studio Troy Tyner/
Henderson Tyner Art Co.
client/service Pam Fish/
production and design
paper Strathmore Elements Grid
colors Two, match
printing Offset lithography
software Aldus FreeHand

concept Designed to communi-
cate the client's new last name,
this stationery does a lot with
only two colors. The gridded
paper adds texture and conveys
some of the technical aspects of
the client's work. The logo, a
registration mark transformed into
a fish by a few dashes of red ink,
further illustrates the client's work
and personality.

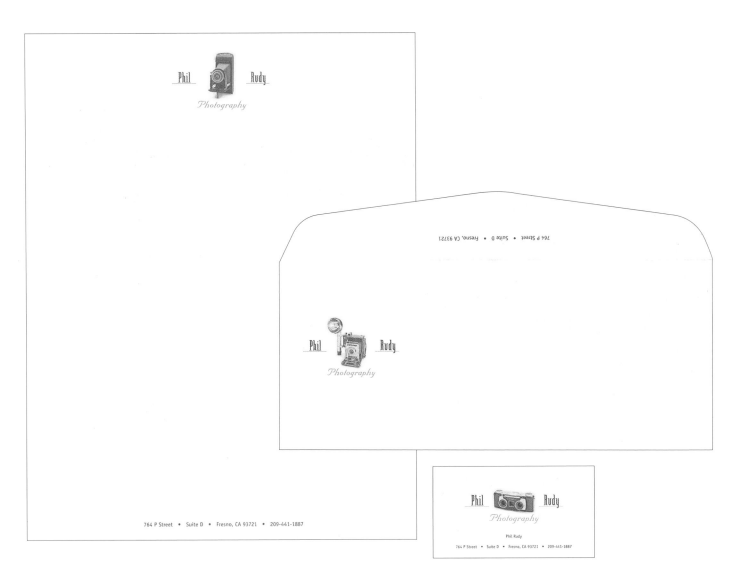

art director/studio Charles Shields/Shields Design

designer/studio Charles Shields/Shields Design

photographer Phil Rudy

client/service Phil Rudy Photography/photographer

paper Strathmore Elements Soft White Dots

type Modula Serif, Nuptial Script (logo); Officina Sans

colors Two, match

printing Offset lithography

software Adobe Illustrator, Adobe Photoshop

concept Photographs taken by the client of old-fashioned cameras represent his business in an unusual way, while contemporary paper and type ensure that no one will mistake his style. Each piece shows a different camera to add variety.

special production technique Photographs were reproduced as duotones for clarity. The mixture of the two match colors created an unusual third.

budget $2,000

cost $1,450

print run 2,000

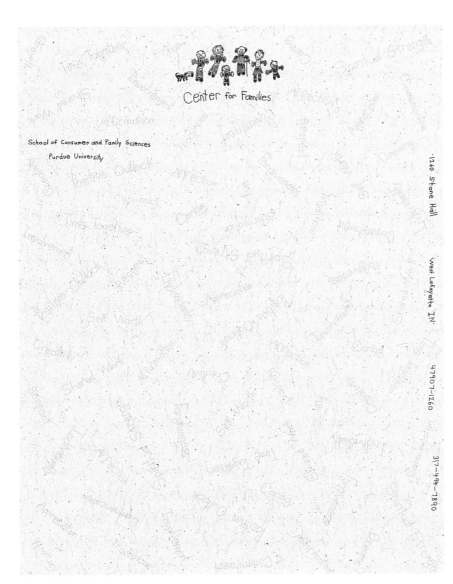

designer/studio Sue Miller/
Purdue University
illustrator Amanda Rush
client Purdue University School of
Consumer and Family Sciences
paper Fox River Writing Confetti,
Ninja
type Univers, hand-lettering
colors Two, match
printing Offset lithography
software Aldus PageMaker

concept Part of a direct-mail
campaign promoting an on-
campus seminar, this letterhead
differentiates itself from campus
mailings by its distinctive artwork,
created by a child.
cost-saving technique A co-work-
er's first-grade daughter provided
the illustrations and lettering for a
five-dollar illustration fee.
cost Part of a $6,800 printing
package including a brochure and
several other pieces.
print run 5,000

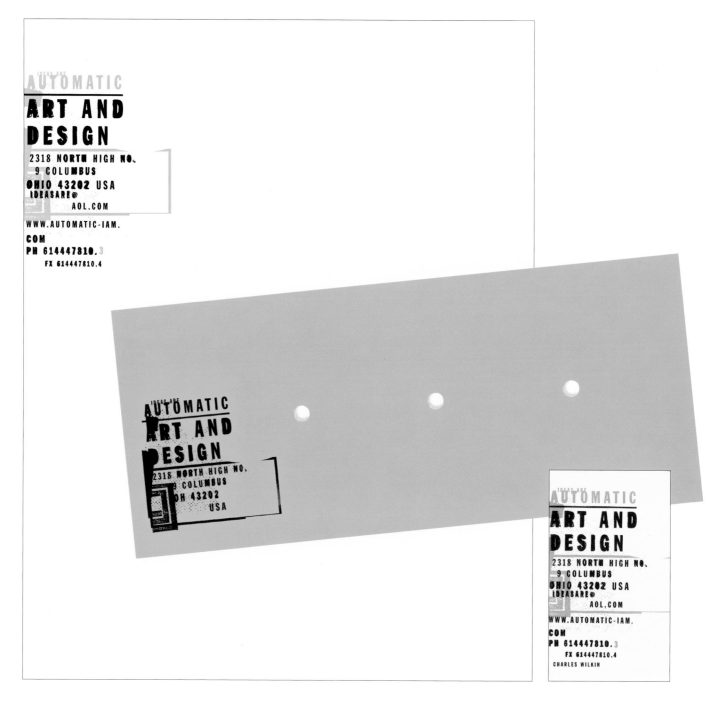

art director/studio Charles Wilkin/
Automatic Art and Design

designer/studio Charles Wilkin/
Automatic Art and Design

client Self

paper French Construction
Whitewash

type Folio Bold Condensed

colors Two, match

printing Offset lithography

software QuarkXPress

concept Sophisticated use of
"distressed" lettering and graphics
make this piece's low budget part
of its charm. The drilled Kraft
envelopes add to its industrial
style.

cost $400

print run 500

art director/studio Rick Tharp/
Tharp Did It
designers/studio Rick Tharp,
Nicole Coleman/Tharp Did It
illustrators Nicole Coleman (type-
writer), Rik Olson (garden glove)
client/service Time-Warner/virtual
garden Web site for gardeners
paper Fox River EverGreen
type Interstate
colors Two, match and copper foil
printing Offset lithography,
letterpress/foil-stamping
software Adobe Illustrator

concept The client wanted a
somewhat earthy feel to present
this digital project in a less
technological way. Illustrations,
foil-stamping and textured paper
give the pieces a "paper" feel,
while green ink and a leaf design
enclosing the Web address visually
connect the pieces to gardening.

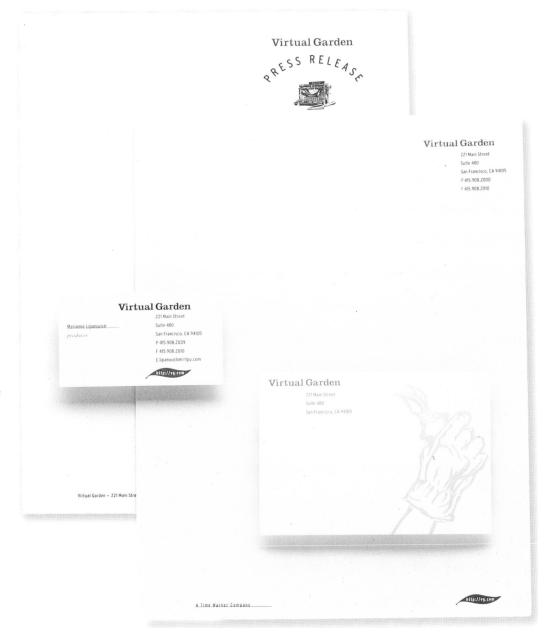

art director/studio John Ball/
Mires Design Inc.

designers/studio John Ball, Jeff
Samaripa, Gretchen Leary/
Mires Design Inc.

client/service Dab Fragrance
Sampling/fragrance samples
distributor

paper Neenah Classic Crest Solar
White

type Futura

colors Match silver plus black

printing Offset lithography

software Adobe Illustrator

concept The simple, strong design
includes a touch of silver for just a
"dab" of glamour. The circular
logo, with its radiating dotted
lines, symbolizes the product.

print run 1,000

1125 MADISON AVENUE
NEW YORK NY 10028

PHONE 800 711 9555
FAX 800 348 1430

1125 MADISON
AVENUE

NEW YORK NY
10028

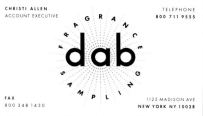

CHRISTI ALLEN
ACCOUNT EXECUTIVE

TELEPHONE
800 711 9555

FAX
800 348 1430

1125 MADISON AVE
NEW YORK NY 10028

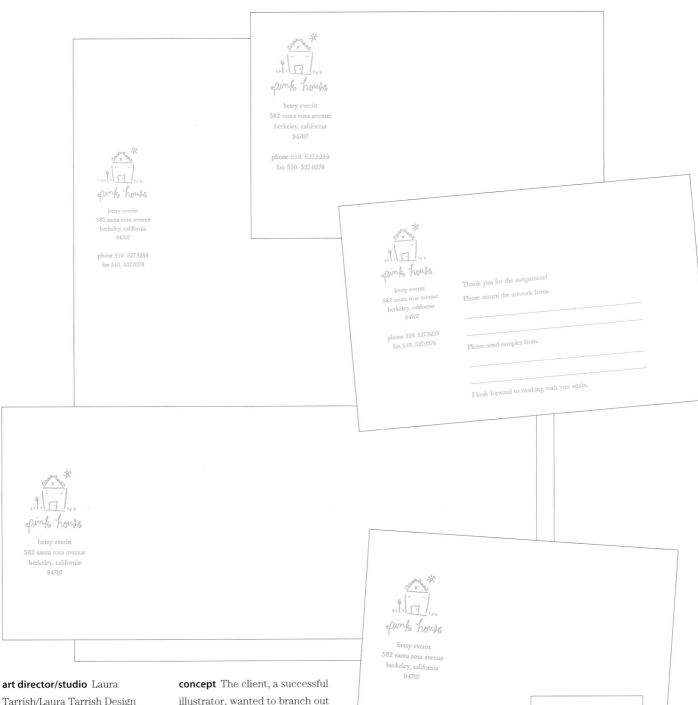

art director/studio Laura Tarrish/Laura Tarrish Design

designer Laura Tarrish/Laura Tarrish Design

illustrator Betsy Everitt

client/service Pink House/fabric design and children's linens

paper Strathmore Writing

type Baskerville Book

colors One, match

printing Offset lithography, letterpress

software QuarkXPress

concept The client, a successful illustrator, wanted to branch out into fabric and linen designs that would feature her distinctive, playful line art. The letterhead package emphasizes her business name and style. Classic letterpress type keeps the design from looking too "cute."

cost $3,800–$4,000

print run 1,000 each (letterhead, second sheets, envelopes, business cards and notepaper sheets); 500 (postcards and mailing labels)

special production techniques

What production technique are you dying to use? Do you find die cuts to die for? Foil-stamping fabulous? Engraving engaging? Everyone has a favorite printing specialty and not enough chances to specify it.

But a spectacular effect is no good on its own. It must fit into a spectacular design and make sense for the client. In this chapter, you'll find a lot of die-cut corners and business cards. You'll find judicious use of metallic ink and foil. You'll even find an elaborate engraved monogram that's not on a wedding invitation (though it was inspired by one).

Whatever the effect, in every case it's the finishing touch on an already great design. As you look at this chapter, imagine each piece without its specialty technique. Not as exciting? True. But strong design nevertheless? Definitely. That's the key to using special techniques. Just as lovely icing can't save a bad cake, printing techniques can't rescue a poor design. But they can make a great design extra special.

art director/studio Serguei Kuzhavsky/OPEN DESIGN!
client/service Lex-Invest/ law services
paper Gallery Art Matte
type Didona, Matrix Script, Letter Gothic
colors Four, process
printing Offset lithography
software Adobe Photoshop, QuarkXPress

concept To convey the tradition and experience of this law firm, the designer scanned an antique book to create an "aged" texture for the background.
budget $7,000
cost $7,000

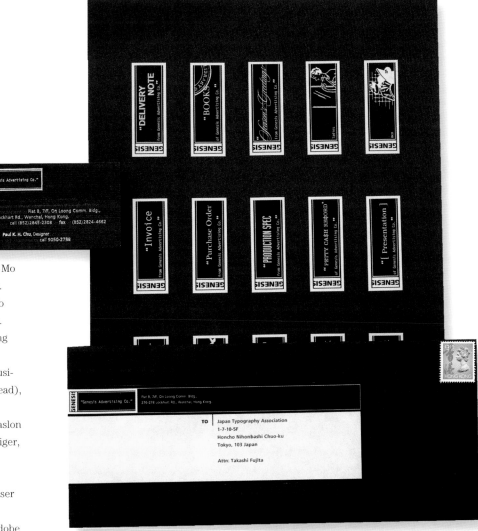

art director/studio James Wai Mo
Leung/Genesis Advertising Co.
designer/studio James Wai Mo
Leung/Genesis Advertising Co.
illustrator James Wai Mo Leung
client Self
paper Curtis Tweedweave (business card), Woodfree (letterhead),
NT Rasha Black (envelope)
type American Typewriter, Caslon
540, Copperplate Gothic, Frutiger,
Letter Gothic, Univers
colors One, match plus black
printing Offset lithography, laser
printing
software Adobe Illustrator, Adobe
Photoshop

concept Instead of a single logo,
the designer created a format consisting of a simple, rectangular
frame—a "screen" that displays
different information or images to
suit the context (invoice, delivery
note, men's and ladies' room
signs). This treatment creates
variety for the system while
retaining a strong, consistent look.
cost-saving techniques The letterhead was printed in only one
color: yellow. The other forms
were printed on the company's
laser printer.
budget $6,500
print run 2,000

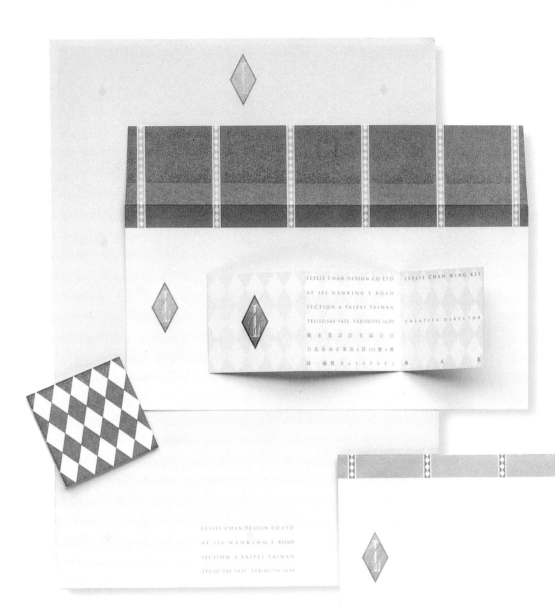

art director/studio Chan Wing Kei (Leslie)/Leslie Chan Design Co., Ltd.

designer/studio Chan Wing Kei (Leslie)/Leslie Chan Design Co., Ltd.

client Self

paper Neenah Classic Crest

type Trajan Bold

colors Two, match metallics

printing Offset lithography, engraving

software Adobe Illustrator, Aldus PageMaker

concept Classic diamond patterns, silver and gold ink and engraving help this designer's stationery stand out from competitors. Gold diamonds printed on the back of the trifold business card and tiny silver diamonds printed on the back of the letterhead sheets add further visual impact. An engraved monogram in a diamond frame decorates each piece.

special production techniques Trifold business cards fold into squares, rather than traditional rectangles. In the monogram, only the letter "c" is engraved for a three-dimensional effect. Envelopes were printed before conversion.

cost $1,500

print run 1,500

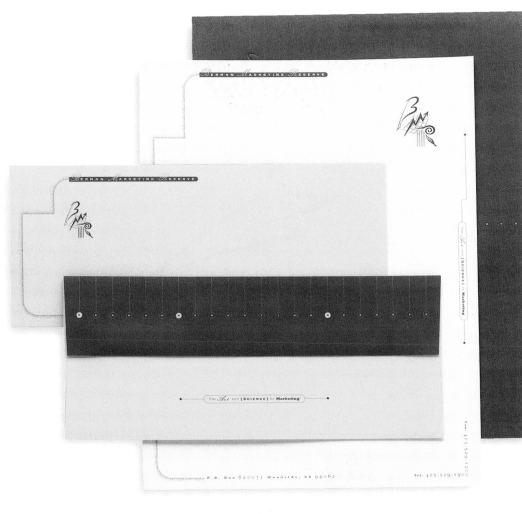

art directors/studio Earl Gee, Fani Chung/Gee + Chung Design

designers/studio Earl Gee, Fani Chung/Gee + Chung Design

illustrator Earl Gee

client/service Berman Marketing Reserve/marketing consulting

paper Champion Benefit Ivory Text (letterhead), Squash Text (envelope), Ochre Cover (business card)

type Kunstler Script, Copperplate 32 B-C (logo); Rockwell Extra Bold and Caslon 540 (text)

colors Two, match (one metallic)

printing Offset lithography, engraving

software QuarkXPress, Adobe Illustrator, Adobe Photoshop

concept Because the firm offers writing, marketing and design services, designers created a logotype transforming the company initials into a quill pen, growth chart and column. This logo and the company motto, "The Art and Science of Marketing," appear on all pieces.

cost-saving technique Using colored paper stocks and screen tints give the impression of more than two colors.

special production techniques Engraving, used on the logotype and various other places, adds texture and a particularly crisp look and makes the metallic ink shine more brightly. The folded and die-cut business cards act as minibrochures for the company. Envelopes were printed before conversion.

print run 2,000

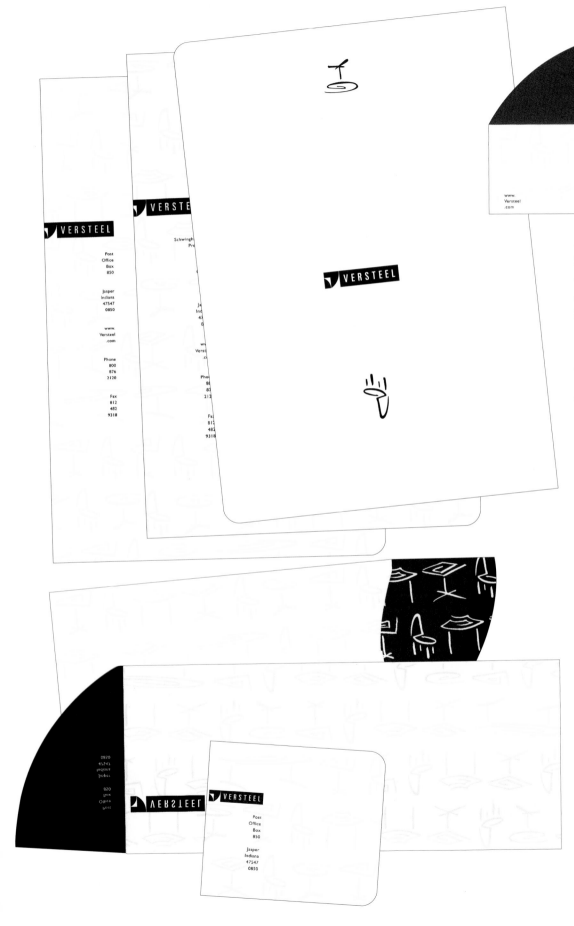

art director/studio Janet Rauscher/Rauscher Design, Inc.
designers/studio Trevor Rowe, Stephanie Hughes, Susan D. Morganti/Rauscher Design, Inc.
illustrator Russ Jackson
client/service Versteel/contract furniture manufacturer
paper Mohawk Superfine Smooth
type Gill Sans
colors Two, match
printing Offset lithography
software QuarkXPress, Aldus FreeHand

concept This new stationery package uses an existing pattern of playfully drawn tables and chairs in a sophisticated way. The impetus was the new corporate logo, which grounds the whimsical illustrations and suggests a solid corporation with sound business policies. The vertical type treatment is distinctive but easy to read and use.

special production techniques
The die-cut, foldover business cards mimic the new logo's shape. Die-cut corners on the right side of all stationery sheets and mailing labels repeat the curving shape and add distinction. The side-opening envelopes, printed before conversion, are especially striking. Their black, die-cut flaps introduce a black interior printed with the signature pattern.
print run 10,000

art director/studio Scott Mires/
Mires Design Inc.

designer/studio Deborah Hom/
Mires Design Inc.

client/service Debra Roberts/
corporate consultant

paper Gilbert Correspond
(letterhead), Neenah Classic Crest
(business card)

type Copperplate (names and
title), New Caledonia (address
and phone number)

colors Two, match (one metallic)

printing Offset lithography,
embossing

software Adobe Illustrator

concept As a one-woman consult-
ing firm working with Fortune 500
companies, the client needed a
solid, memorable image. Elegant
type and horizontal stripes make a
distinct impression. The stripes,
printed in green-gold ink with a

subtle metallic shine, are not
overused; they're saved for the
business cards and envelope flaps,
and the reverse side of the letter-
head sheet.

special production techniques
Stripes are embossed in the busi-
ness card for added effect. The
company name is also printed on
the back of the letterhead, so that

when letters are folded, they still
carry the company name.

budget $5,000

cost $8,000

print run 500 (business cards);
2,000 (letterhead and envelopes)

design director/studio Patrick Short/BlackBird Creative

designers/studio Patrick Short, Kristy Beausoleil/BlackBird Creative

Production Joy Crouch

client/service Nomad Short Subjects/film directing and writing

paper Various (letterhead), used file folders (business cards), Kraft Glove Envelopes (envelopes), Fasson Crack'N Peel Buff Pastel Stock (labels)

type Helvetica, various

colors Three, match

printing Offset lithography, engraving

software QuarkXPress, Adobe Photoshop

concept Printed and debossed labels inspired by passports transform any paper into stationery for this firm. In fact, the more "ordinary" the paper (examples here are newsprint and lined school paper), the more stylish the look. Dotted lines on the labels, which can also be used to identify videotapes, props and other company property, allow them to be updated for any location.

special production techniques The company name and names of the principals were debossed for a professional look. A background pattern, type and frame were "roughed up" for a weathered look.

budget $6,000

cost $5,400 plus swap of creative time

print run 5,000

art director/studio Carlos Segura/
Segura Inc.
designer/studio Carlos Segura/
Segura Inc.
illustrator Carlos Segura
client Self
colors Two, match
printing Letterpress
software Adobe Illustrator

concept Known for contemporary type design and layered, sometimes inscrutable graphics, Segura surprises with this classic letterhead package. Using simple brown and black type on cream paper, with added dignity from letterpress printing, this package exudes calm and confidence. But further surprises await. A second envelope design shocks with its heavy rocklike design and textured paper. And a textured fabric portfolio, seemingly nailed shut, holds a demo CD. Its four-color cover, printed on textured paper, introduces a CD printed with a version of the cover as well as the firm's address and logo.
budget $3,000
print run 5,000

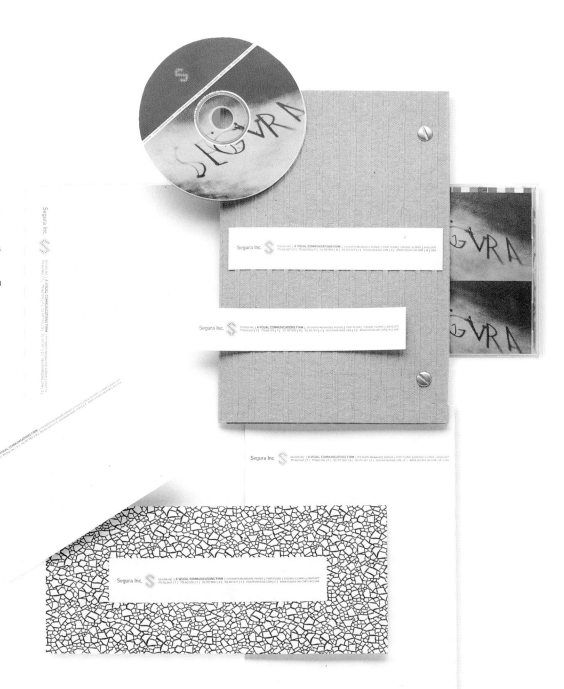

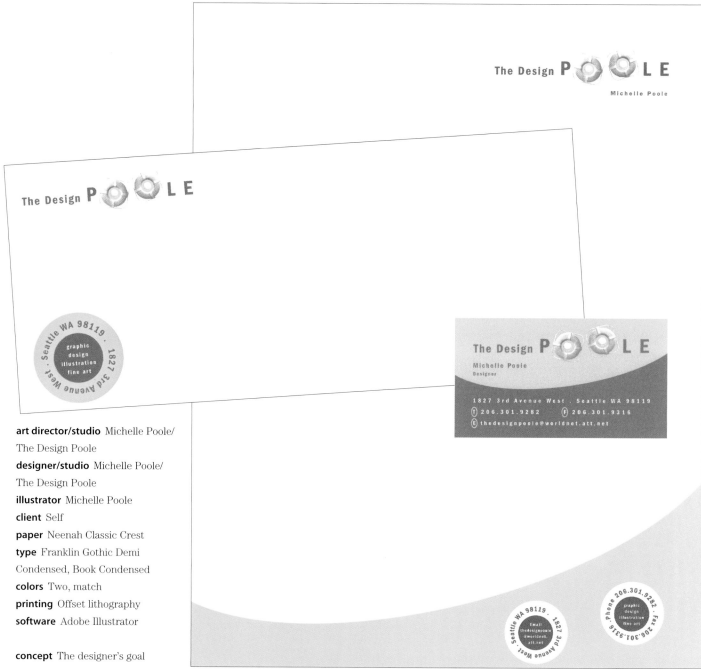

art director/studio Michelle Poole/
The Design Poole

designer/studio Michelle Poole/
The Design Poole

illustrator Michelle Poole

client Self

paper Neenah Classic Crest

type Franklin Gothic Demi
Condensed, Book Condensed

colors Two, match

printing Offset lithography

software Adobe Illustrator

concept The designer's goal
was to create a memorable and
creative set, focusing particularly
on the business card, which would
reinforce the firm name without
being cute. Her solution was a
package subtly implying that The
Design Poole is a "life preserver"
for clients. The company name
sets the tone. Wave shapes, bright
pastel "beach" colors and type
set in life-preserver-inspired
circles reinforce the idea without
overloading it.

cost-saving technique The
designer traded services for
printing.

special production technique
Die-cut holes through the life
preserver "o"s in all pieces invite
clients to peer through them.

budget $1,500

cost $0

print run 1,000

art director/studio Petrula
Vrontikis/Vrontikis Design Office
designers/studio Victor Corpuz
(logo), Winnie Li (stationery)/
Vrontikis Design Office
client/service MAMA Records/
MAMA Foundation/jazz music
foundation and recording label
paper Champion Benefit
type Bell Gothic
colors Two, match
printing Offset lithography
software QuarkXPress

concept This distinctive package
has none of the inexpensive look
too commonly attributed to one-
color design. Although each of the
pieces is printed in only one color,
colored papers and screen tones
give the look of at least three col-
ors per piece. The piano key logo,
die cut into all letterhead sheets,
adds an elegant but understated
touch.

special production techniques
Stationery was die cut
and envelopes were
printed before conver-
sion.
cost $12,000
print run 2,500

art director/studio Matt Graif/ Graif Design

designer/studio Matt Graif/ Graif Design

client/service The Ticket Center/law services

paper Fox River EverGreen

type Futura, Big House

colors Two, match

printing Offset lithography

software Adobe Illustrator

concept This package for a law firm takes a humorous look at getting tickets from police. The design is inspired by actual tickets and includes a company logo in the shape of a police badge. Screen tones give this piece the look of additional ink colors, while textured paper adds to the visual impact.

special production techniques Letterhead sheets are die cut and perforated to resemble police tickets.

budget $1,500

cost $4,000

print run 1,000

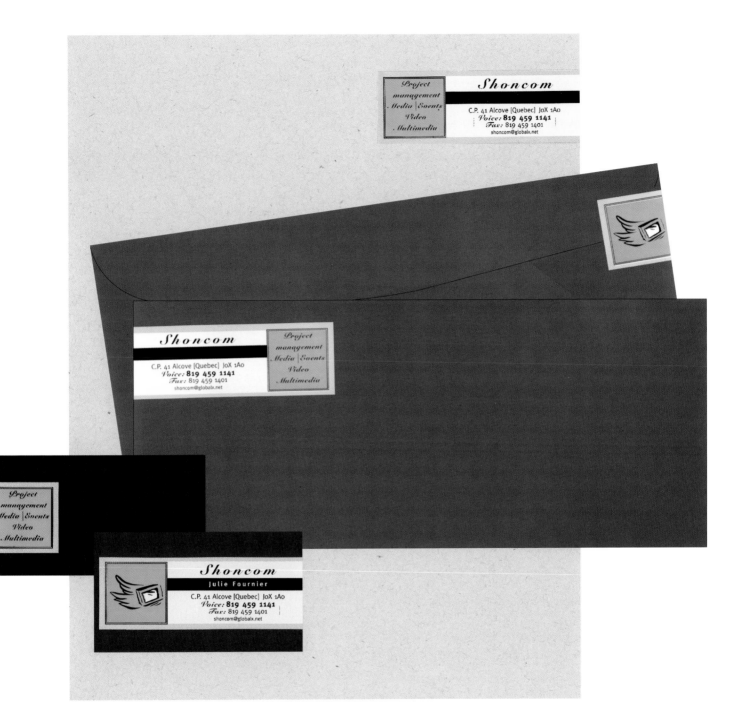

art director/studio Jean-Luc Denat/Aartvark Communications
designer/studio Jean-Luc Denat/Aartvark Communications
illustrator Romi Caron
client/service Shoncom/project manager, special event coordinator

paper Hopper
type Meta-Normal (address), Snell Roundhand
colors Two, match
printing Screenprinting
software QuarkXPress, Adobe Illustrator

concept Unusually colored papers give this piece its greatest impact. Screenprinted labels, folded over all pieces in one of two ways, give the look of printing on two sides. Their extra bright, thick screen-printing ink adds texture as well as saturated color.

special production technique Printing was confined to hand-applied labels.
budget $5,000
cost $5,000
print run 1,000

art director/studio Juli Shore/Jart Design and Illustration
designer/studio Juli Shore/Jart Design and Illustration
illustrator Tess Loo
client/service La Boheme/ "cultural artifacts" shop
paper Fox River Confetti Rust (business card), Neenah UV Ultra II Sepia (letterhead), Neenah Environment Sedona Red (envelope)
type Marydale
colors Two, match (one metallic; business card); one, match (envelope and letterhead)
printing Offset lithography, thermography
software Aldus FreeHand

concept The distinctive die-cut business card is the cornerstone of this piece for a store that sells furniture, vessels, rugs and textiles. Printed in black thermographic ink backed with a match metallic copper, the cards are shaped like baskets made in Thailand, where much of the store's products are from. The earth-toned papers match the store's color scheme and inventory.

cost-saving technique The letterhead and envelopes are printed in only one color.

special production technique The metallic copper was custom-mixed with white to achieve an ink that would be visible on the rust-colored paper.

budget $1,500
cost $1,778 plus merchandise trade
print run 2,000 (business cards); 500 (letterhead and envelopes)

art directors/studio Peter Scott, Glenda Rissman/Q30 Design Inc.
designer/studio Martin Riess/Q30 Design Inc.
photographer Colin Faulkner
client/service Anstey Book Binding Inc./bookbinding and specialty printing

paper Neenah Classic Columns, FasTrack (labels)
type City (identity), News Gothic
colors Four, match
printing Offset lithography, letterpress
software QuarkXPress, Adobe Illustrator, Adobe Photoshop

concept This collaborative project between the designer and printer was created to show, and be a concrete example of, the client's capabilities. Photographs show details of bookbinding in action. Letterpress printing, die cutting and folding show some of the client's printing services, all of which are listed on the letterhead and reverse side of the business cards. Textured paper adds a sumptuous feel.
print run 2,000

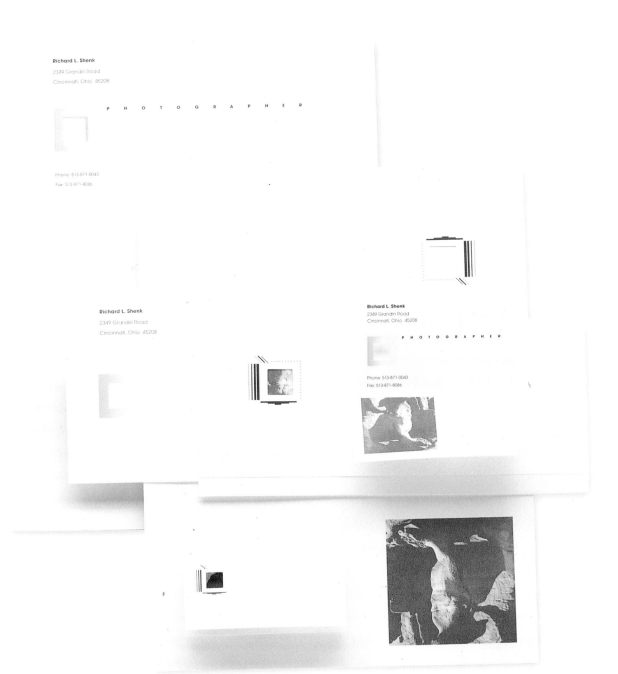

art director/studio Stan Brod/
Wood/Brod Design
designer/studio Stan Brod/
Wood/Brod Design
photographer Richard L. Shenk
client/service Richard L. Shenk/
photographer

paper Strathmore Writing 25%
Rag
type Helvetica, Helvetica Bold
colors Match silver plus black
printing Offset lithography, laser
printing
software Adobe Illustrator

concept This simple piece plays
on the client's business—photog-
raphy. Die-cut squares allow
potential clients to peek through a
lens at a photograph. For clarity,
the photo is printed as a black-
and-silver duotone.

special production techniques On
business cards, a glimpse of the
photo is accomplished by a
foldover cover. On letterhead, the
photo is printed on the back of the

sheet so that it will be visible after
the letter is folded. The photo is
much larger than the die-cut
square, which is intriguing to the
viewer and doesn't demand exact
registration.

budget $5,000
cost $4,865
print run 2,500 (letterhead);
3,000 (envelopes); 1,000 (busi-
ness cards)

art director/studio Frank Viva/
Viva Dolan Communications and
Design, Inc.
designer/studio Victoria
Primicias/Viva Dolan
Communications and Design, Inc.
client/service Opal Sky Inc./
software
paper Unipaque Offset
type Engravers Gothic, Trade
Gothic Extended
colors Three, match
(one metallic)
printing Offset lithography
software QuarkXPress

concept The sans serif face and
Spirograph image ground the
firm's poetic name and refer to its
strength—mathematics. Two-
sided printing on vellum paper
makes a distinctive impression
and refers obliquely to the name,
as does the metallic blue ink.
special production technique
The firm's name is printed back-
ward on the reverse side of the
letterhead and business card, so it
can be read through the translu-
cent paper.
cost $10,000
print run 2,000

art director/studio Frank Viva/
Viva Dolan Communications and
Design, Inc.
designer/studio Julie Opatovsky/
Viva Dolan Communications and
Design, Inc.
illustrator Clip art
client/service Conqueror Fine
Papers/paper manufacturer
paper Conqueror Ultra White
Wove
type Kaufman, Trade Gothic
colors Four, process
printing Offset lithography
software QuarkXPress

concept One of a series of fake
letterheads used to show off
Conqueror papers, this one used
three-dimensional printing to
show cartoonish figures jumping
for joy. The three-dimensional
glasses were imprinted by the
manufacturer. Joke address infor-
mation was aligned with the illus-
trations in a creative but read-
able way.
special production technique
The three-dimensional
images were created
using a special formula.
print run 5,000

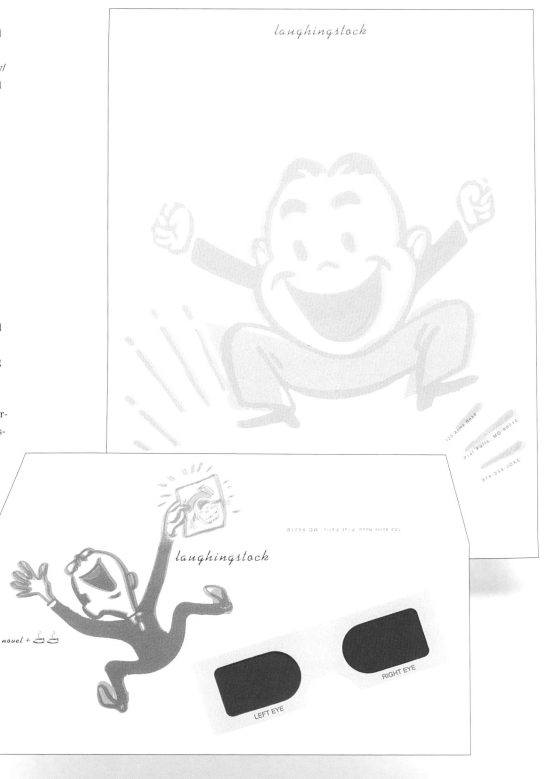

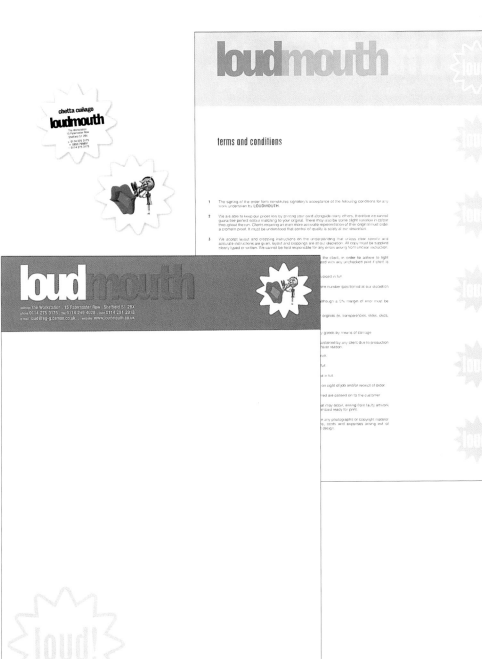

art director/studio Dom Raban/
Eg.G
designer/studio Neil Carter/Eg.G
client/service Loudmouth/
postcard production
paper Snowcap
colors Two, match (letterhead);
four, process (card)
printing Offset lithography
software Infini-D, Adobe
Illustrator

concept This stationery package
also serves as a contract form for
the postcard printer. Terms and
conditions are printed in one color
on the back. The three-dimensional
illustration is a portrait of the
proprietor.
special production techniques
The three-dimensional illustration
was created with special software.
Four-color business cards printed
by the client were die cut into a
"loud" symbol.
cost £800
print run 5,000

art director/studio Marianne Mitten/Mitten Design
designer/studio Marianne Mitten/Mitten Design
client/service Christopher and Dana Dworin/personal stationery

paper Strathmore Soft White Wove
type Stuyvesant
colors Two, match (one metallic)
printing Offset lithography, engraving
software QuarkXPress

concept This elegant stationery was inspired by the client's wedding invitation. The designer used a similar monogram on the invitation as her model, redrawing it and adding detail. The engraved name and address information was printed with metallic ink.

special production technique The monogram was offset printed with a registered, embossed, sculpted die.
cost-saving technique The same die was used on both pieces.
budget $3,800
cost $3,500
print run 2,000

Strategic Design
for Online Environments

4016 Farm Hill Blvd #103
Redwood City, California
94061-1017

Tel 415.369.0313
Fax 415.369.0939

amyjo@naima.com
http://www.naima.com

Amy Jo Kim
Creative Director

4016 Farm Hill Blvd #103
Redwood City, California
94061-1017

Tel 415.369.0313
Fax 415.369.0939

amyjo@naima.com
http://www.naima.com

Strategic Design for Online Environments

printing Offset lithography, embossing, debossing
software QuarkXPress

concept Motion and emotion are both implied in this stationery package for a design firm specializing in online design. Embossing and debossing refer to interactivity, while the pattern of sunlight on water, printed inside a curved line, recalls fluid motion and a combination of sight and sound, all tools of the online designer.

special production techniques The letters of the company name were alternately embossed and debossed on the letterhead and business cards. The side-opening envelope was printed before conversion. Its flap was die cut in a wave shape.

print run 500

art director/studio Tracy Moon/ AERIAL
designer/studio Tracy Moon/ AERIAL
client/service NAIMA/online environmental design firm
paper Neenah Classic Crest Solar White Cover (business card), Text (letterhead)
type Futura Condensed
colors Two, match

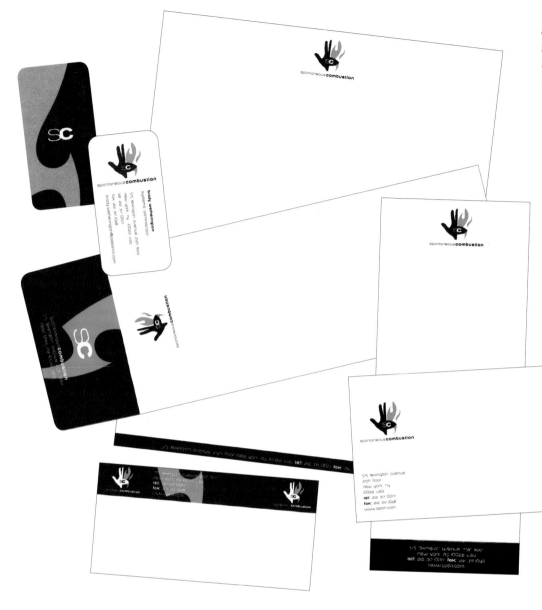

art director/studio Carlos Segura/
Segura Inc.
designer/studio Colin Metcalf/
Segura Inc.
illustrator Colin Metcalf
client/service Spontaneous
Combustion/film production
type Babymine from [t-26]
colors Two, match
printing Letterpress
software Adobe Illustrator,
QuarkXPress

concept The simple combination
of black and orange colors and
a provocative logo ignite this
package. Side-opening envelopes
and die-cut business cards printed
on unusually heavy card stock
provide interesting
tactile notes, but
the company's
logo, a hand
bursting into
flame, remains the
graphic focus. It
represents the
company's hands-
on approach to
film editing, as well as literally
interpreting the name.
print run 10,000

art director/studio Rick Tharp/ Tharp Did It

designers Rick Tharp, Nicole Coleman

client/service Texas Tea Service/ mobile oil change

paper Fox River Starwhite Vicksburg

type Helvetica Compressed (logo), Univers Condensed, Century

colors Black plus silver foil

printing Offset lithography, letterpress/foil-stamping

software Adobe Illustrator

concept Foil-stamping provides the distinctive look for this piece—stationery for an upscale oil change service. The name comes from a slang term for oil. The humorous logo combines a teacup and funnel. Silver foil implies that this funnel is part of a silver "service." The bottom of the business card contains address and phone information reversed out of solid black. On the back of the card, the black square becomes an oil gauge.

special production technique Foil-stamping.

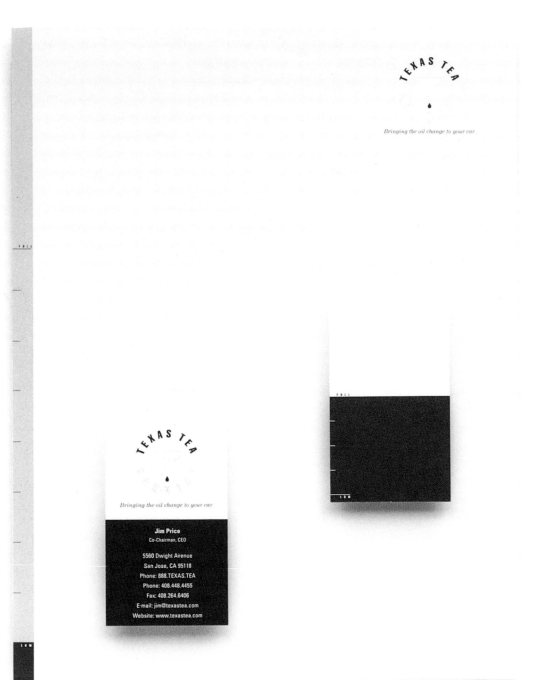

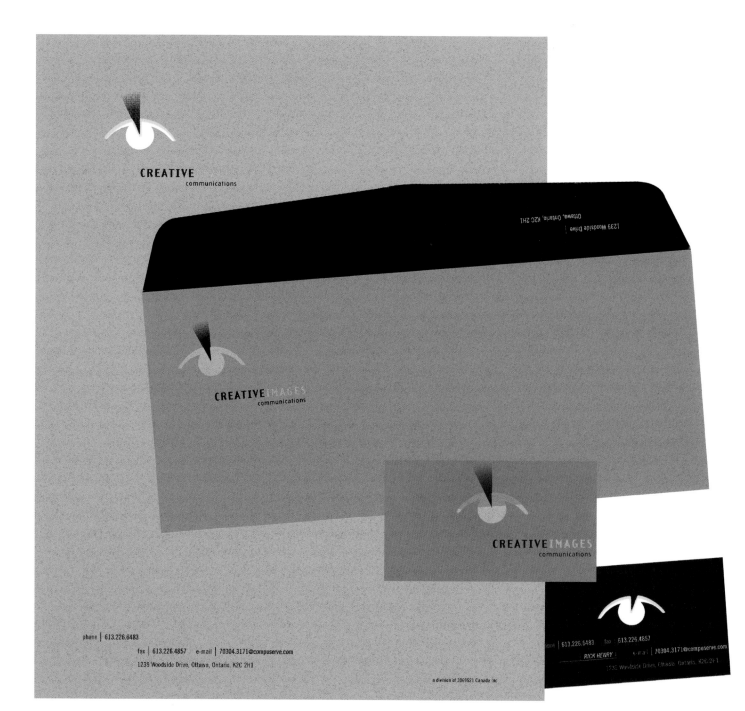

art director/studio Jean-Luc Denat/Aartvark Communications
designer Mario L'Écuyer
illustrator Mario L'Écuyer
client/service Creative Images Communications/special effects for video

paper Beckett Concept
type Arbitrary Sans (logo), Trade Gothic Condensed (address)
colors Two, match (one metallic)
printing Offset lithography
software QuarkXPress, Adobe Illustrator

concept A die-cut eye on all pieces creates an ever-changing view. Recipients can see their hands through the business card, a sheet of paper through the envelope, the top of their desks through the letterhead. Colored paper and metallic silver ink bring further visual interest to the piece.

cost-saving technique The same die was used for all pieces.
special production techniques The logo was created with a custom die. Custom envelopes were printed and die cut before conversion.
cost $5,000 (Canadian)
print run 1,000

art director/studio Rick Tharp/
Tharp Did It
designers Rick Tharp, Susan Craft
client/service Cosmopolitan Grill/
restaurant
paper Fox River Sundance
type Hand-lettering (logo),
Minion
colors Two, match (one metallic),
plus foil
printing Offset lithography,
letterpress/foil-stamping
software Adobe Illustrator

concept Part of an overall identity
package for a new restaurant, this
stationery set repeats the colors
used in the interior design as well
as the shape of its custom bar
stools. The identity is ghosted
on the front of the two-color
stationery for an elegant, under-
stated look. Custom-shaped
business cards are flashier—one
side is printed in metallic ink with
the logo reversed out. On the
other side, the restaurant's name
is stamped in gold foil.
special production technique A
custom die cut the foil-stamped
business cards into the shape of
the restaurant's custom bar stools.

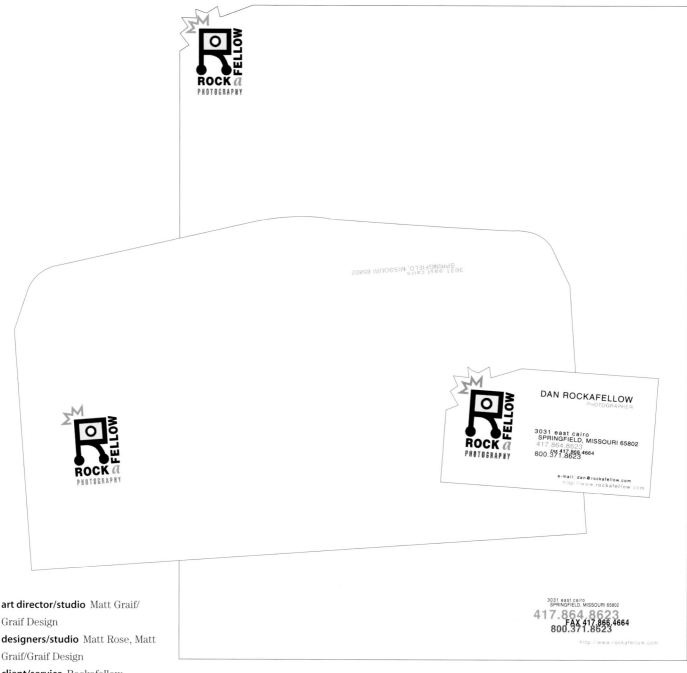

art director/studio Matt Graif/
Graif Design
designers/studio Matt Rose, Matt
Graif/Graif Design
client/service Rockafellow
Photography/commercial
photography
paper Neenah Classic Crest
type Helvetica
colors Three, match
printing Offset lithography
software Adobe Illustrator

concept Because the photograph-
er worked for advertising agen-
cies, his letterhead needed to
appeal to them by demanding
attention and demonstrating a
fresh approach to photography.
Rather than using examples of the
client's work, this package used
his name as the base for a whimsi-
cal illustration of a camera. Die-
cut corners and a contemporary
type treatment added a finishing
touch.

cost-saving technique The same
die was used on both the letter-
head and card.
budget $1,200
cost $3,000
print run 750

COPYRIGHT NOTICES

DIRECTORY OF DESIGN FIRMS

Aartvark Communications
134 St. Paul St., 2nd Floor
Vanier, Ontario K1L 8E4
Canada

AERIAL
58 Federal St.
San Francisco, CA 94107

A-Hill Design
121 Tijeras NE, Ste. 220D
Albuquerque, NM 87102

Amryliw
Model House Craft & Design
Centre
Llantrisant, Wales CF72 8EB
United Kingdom

Art O Mat Design
85 S. Washington, Ste. 310
Seattle, WA 98104

Automatic Art and Design
2318 N. High #9
Columbus, OH 43202

Backbone Design
427 Anderson Ct.
Orlando, FL 32801

Back Yard Design
211 E. 49th St.
New York, NY 10017

Baker Design Associates
1411 7th St.
Santa Monica, CA 90401

Big Eye Creative, Inc.
1300 Richards St., Ste. 101
Vancouver, British Columbia V6B
3G6
Canada

BlackBird Creative
100 N. Tryon St., Ste. 2800
Charlotte, NC 28202

Bradbury Design Inc.
1933 8th Ave., Ste. 330
Regina, Saskatchewan S4R 1E9
Canada

Cahan & Associates
818 Brannan, Ste. 300
San Francisco, CA 94103

Canary Studios
600 Grand Avenue, Ste. 307
Oakland, CA 94610

Carbone Smolan Associates
22 W. 19th St., 10th Floor
New York, NY 10011

David Carter Design Associates
4112 Swiss Ave.
Dallas, TX 75204

Design Center
15119 Minnetonka Blvd.
Minnetonka, MN 55345

The Design Poole
1827 3rd Ave. W., #C
Seattle, WA 98119

Disney® Design Group
Walt Disney World®
P.O. Box 10,000
Lake Buena Vista, FL 32830

Dupla Design
Rua Gavião Peixoto
183/1403 Icarai
Niterói, Rio de Janeiro
Brazil 24.230-091

Dyad Communications, Inc.
303 N. 3rd St.
Philadelphia, PA 19106

Eg.G
The Workstation
15 Paternoster Row
Sheffield, England S1 2BX
United Kingdom

Elena Design
3024 Old Orchard Ln.
Bedford, TX 76021

FitzMartin
402 Office Park Dr., Ste. 101
Birmingham, AL 35223

Gee + Chung Design
38 Bryant St., Ste. 100
San Francisco, CA 94105

Genesis Advertising Co.
Flat B, 7/F, On Loong Comm.
Bldg.
276-278 Lockhart Rd.
Wanchai
Hong Kong

Grafik Communications, Ltd.
1199 N. Fairfax St., Ste. 700
Alexandria, VA 22314

Graif Design
1330 W. Schatz Ln., Ste. 4
Nixa, MO 65714

Hal Apple Design, Inc.
1112 Ocean Dr., Ste. 203
Manhattan Beach, CA 90266

Henderson Tyner Art Co.
315 N. Spruce St., Ste. 299
Winston-Salem, NC 27101

**Hornall Anderson Design Works,
Inc.**
1008 Western Ave., Ste. 600
Seattle, WA 98104

**Images Graphic Design &
Illustration**
P.O. Box 222
The Lake House Main Street
Grafton, VT 05146

Jart Design
P.O. Box 3403
100 West Colorado, Ste. 209
Telluride, CO 81435

Kan & Lau Design Consultants
28/F Great Smart Tower
230 Wanchai Road
Wanchai
Hong Kong

Kiku Obata & Company, Inc.
5585 Pershing Ave., Ste. 240
St. Louis, MO 63112

Kilmer & Kilmer
125 Truman NE, Ste. 200
Albuquerque, NM 87108

K.-O. création
6300 av. du Parc #420
Montreal, Quebec H2V 4H8
Canada

Labbé Design Co.
2046 NW Flanders, No. 34
Portland, OR 97209

Laura Tarrish Design
2450 SW Sherwood Dr.
Portland, OR 97201

Leslie Chan Design Co., Ltd.
4F, 115 Nanking E. Rd., Sect. 4
Taipei, Taiwan

lima design
215 Hanover St.
Boston, MA 02113

Margo Chase Design
2255 Bancroft Ave.
Los Angeles, CA 90039

May & Co.
5401 N. Central Expressway,
Ste. 325
Dallas, TX 75205

Merge Design Inc.
1708 Peachtree St., Ste. 100
Atlanta, GA 30309

Mike Salisbury Communications, Inc.
4223 Glencoe Ave., Ste. A220
Marina del Rey, CA 90292

Mires Design Inc.
2345 Kettner Blvd.
San Diego, CA 92101

Mitten Design
604 Mission St., Ste. 820
San Francisco, CA 94105

Neo Design, Inc.
1048 Potomac St., NW
Washington, DC 20007

OPEN DESIGN!
P.O. Box 412
Moscow
Russia 103064

Oxygen, Inc.
1552 N. Wells Street #2R
Chicago, IL 60610

Paul Gardner
37A Bedford St.
New York, NY 10014

Pisarkiewicz Mazur & Co., Inc.
1 Wall Street Ct.
New York, NY 10005

plus design inc.
25 Drydock Ave.
Boston, MA 02210

Purdue University
West Lafayette, IN 47907

Q30 Design Inc.
489 King St. W., Ste. 400
Toronto, Ontario M5V 1K4
Canada

Rauscher Design, Inc.
1501 Story Ave.
Louisville, KY 40206

Real Art Design Group, Inc.
232 E. 6th St.
Dayton, OH 45402-2837

Renée Rech Design
428 Channing Avenue
Palo Alto, CA 94301

Rick Sealock Illustration
P.O. Box 98
Milo, Alberta TOL 1LO
Canada

Sayles Graphic Design
308 Eighth St.
Des Moines, IA 50309

Segura Inc.
1110 N. Milwaukee Ave.
Chicago, IL 60622-4017

Shapiro Design Associates Inc.
10 E. 40th St.
New York, NY 10016

Shields Design
415 E. Olive Ave.
Fresno, CA 93728

Siebert Design
1600 Sycamore
Cincinnati, OH 45210

Smart Works Pty. Ltd.
113 Ferrars St.
Southbank, Victoria 3006
Australia

Spring. Design Group, Inc.
14 Bond St., Ste. 120
Great Neck, NY 11021

Steven R. Gilmore/SRG Design
8702 Chalmers Dr.
Los Angeles, CA 90035

Swieter Design U.S.
3227 McKinney, Ste. 201
Dallas, TX 75204

Ted Bertz Graphic Design, Inc.
190 Washington St.
Middletown, CT 06457

Tharp & Drummond Did It
1238A NW Glisan St.
Portland, OR 97209

Tharp Did It
50 University Ave., Ste. 21
Los Gatos, CA 95030

2Rebels/K.-O. création
6300 av. du Parc #420
Montreal, Quebec H2V 4H8
Canada

Viva Dolan Communications and Design, Inc.
1216 Yonge St., Ste. 203
Toronto, Ontario M4T 1W1
Canada

Vrontikis Design Office
2021 Pontius Ave.
Los Angeles, CA 90025

Walker Creative, Inc.
311 W. Dixon, Ste. 202
Fayetteville, AR 72701

Wood/Brod Design
2401 Ingleside Ave.
Cincinnati, OH 45206

INDEX OF CLIENTS

INDEX OF DESIGN FIRMS

Got some fresh ideas of your own that you'd like to share with us?

If you'd like to be put on our mailing list to receive a call for entries for future Fresh Ideas books, please copy the form below (or include the same information in a note to us) and send it to:

Linda Hwang

Fresh Ideas Mailing List

North Light Books

1507 Dana Avenue

Cincinnati, Ohio 45207

or call Linda Hwang at (513) 531-2222, or fax her at (513) 531-7107.

Who knows—maybe you'll see your own work in the next Fresh Ideas book!

Please put me on your mailing list to receive calls for entries for future Fresh Ideas books.

My name _____

Studio name _____

Address _____

City_____

State _____ Zip Code _____

Phone_____

Fax_____